CATS ON CATNIP

Andrew Marttila

Running Press
PHILADELPHIA

Running Press
Hachette Book Group
1290 Avenue of the Americas, New York, NY 10104
www.runningpress.com
@Running_Press

Printed in China

First Edition: June 2018

Published by Running Press, an imprint of Perseus Books, LLC, a subsidiary of Hachette Book Group, Inc. The Running Press name and logo is a trademark of the Hachette Book Group.

The Hachette Speakers Bureau provides a wide range of authors for speaking events. To find out more, go to www.hachettespeakersbureau.com or call (866) 376-6591.

The publisher is not responsible for websites (or their content) that are not owned by the publisher.

Print book cover and interior design by Ashley Todd.

Library of Congress Control Number: 2017953523

ISBNs: 978-0-7624-6367-1 (hardcover),
978-0-7624-6368-8 (ebook)

LREX

10 9 8 7 6 5

FOR SHIRA

INTRODUCTION

Most of us would agree that cats are agile, regal creatures, but if you believe that cats are nothing but grace and sophistication, then you've probably never seen a cat on catnip.

I've been a professional animal photographer for the past five years and have dedicated most of that time to photographing cats exclusively. When photographing cats, the attitude is as important as the gear—patience, good lighting, and a fast shutter speed go a long way. With my setup I'm able to capture pictures at split seconds, catching a cat's wildest faces and expressions that would otherwise just be a hilarious moving show. I graduated with a degree in neuroscience, but I never imagined it would evolve into exploring the neuro-effects of catnip. Yet, these photos are enough to make any cat lover wonder what is causing this hysterical response.

Catnip, or *Nepeta cataria*, grows rather unfettered in the wild in many parts of the world and is extremely easy to grow at home in most climates. It's part of the mint family and contained within the bulbs, stems, and leaves is an oil called nepetalactone. Once eaten, rolled on, or crushed, the oil binds to the cat's nasal receptors and stimulates a response that affects a number of areas in the brain, including the hypothalamus and amygdala, two regions

that are key in regulating emotional and behavioral responses to stimuli. This often causes cats to rub their face and body all over the green stuff, which produces a mild euphoric effect and typically lasts about ten to twenty minutes.

Catnip releases something primordial within cats. Carefree and unconstrained, they are free to be silly, exceptionally playful, and downright gnarly. Delightful, elegant Fluffy transforms into a hell-bent renegade. Shy, reserved Mittens becomes a free-loving acrobat. In the blink of an eye, a cat's expression transforms from bored to inquisitive to playful to curious to bizarre . . . to utterly unhinged.

In my experience meeting hundreds of cats and kittens through my camera lens, only about four in five adult cats react to catnip, and most are immune to its effects until they're about four to six months old. I've tested catnip on dozens of kittens and only a handful have reacted.

I've actually known many of the cats and kittens who are featured in this book their entire lives. I rescue and raise orphan kittens with my partner Hannah Shaw (Kitten Lady), and many of the models were hand-raised by us since they were newborns. Tidbit, for instance, was brought to us when he was found outside without a mother at just one day old. In creating this book, I was able to visit many of our rescues in their adoptive homes and was incredibly happy to see them living the high (*ahem*) life.

While creating this book, I was astounded to discover how few people have witnessed their cats on catnip, or when they did, what paltry amounts they offered. Since starting this project, I have gone through roughly three pounds of catnip. If I have one lesson to impart, it is this: Don't be stingy. Catnip is non-addictive and harmless and provides a temporary respite from your cat's grueling workload of napping all day.

Give your cat a pile of catnip and let the party begin.

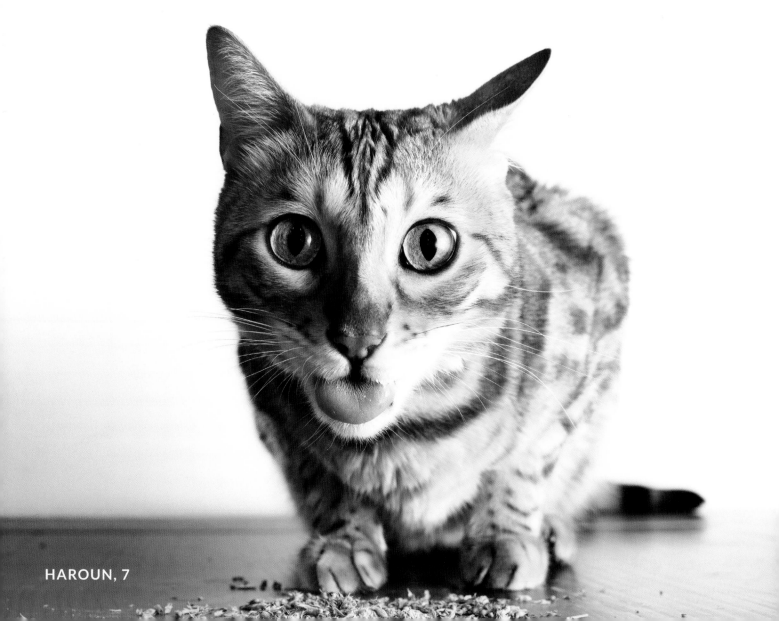
HAROUN, 7

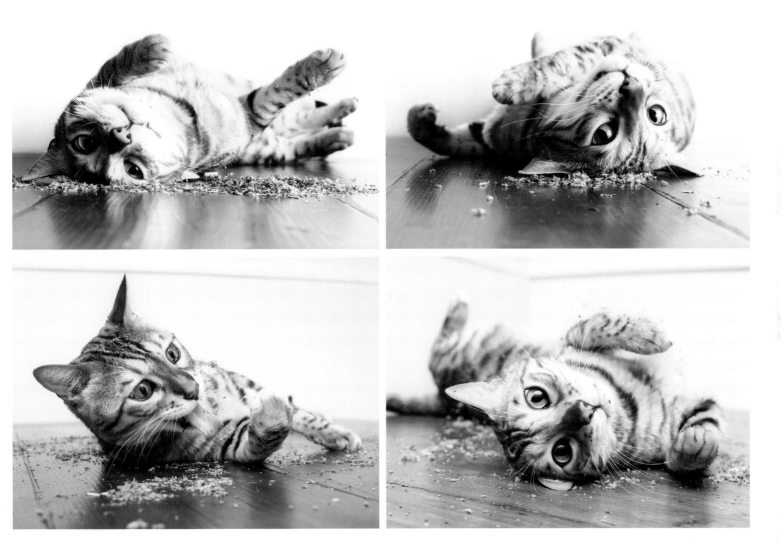

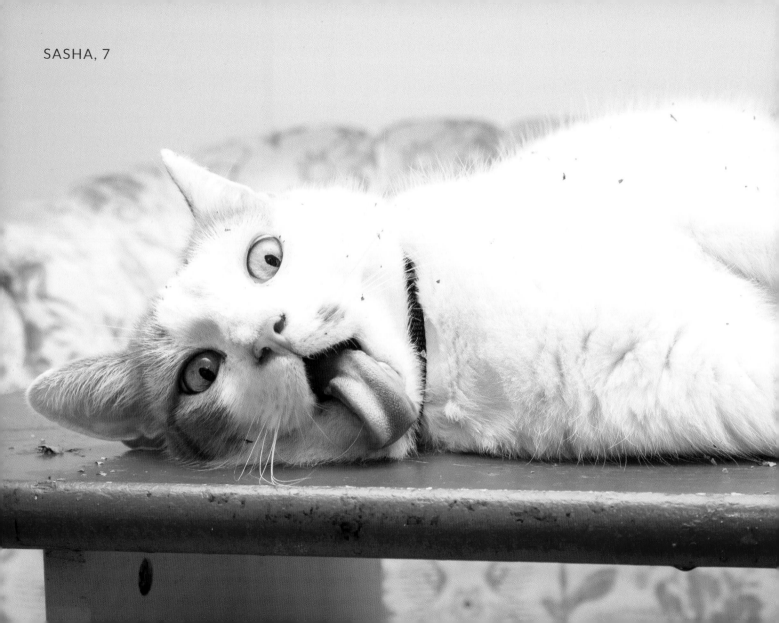

SASHA, 7

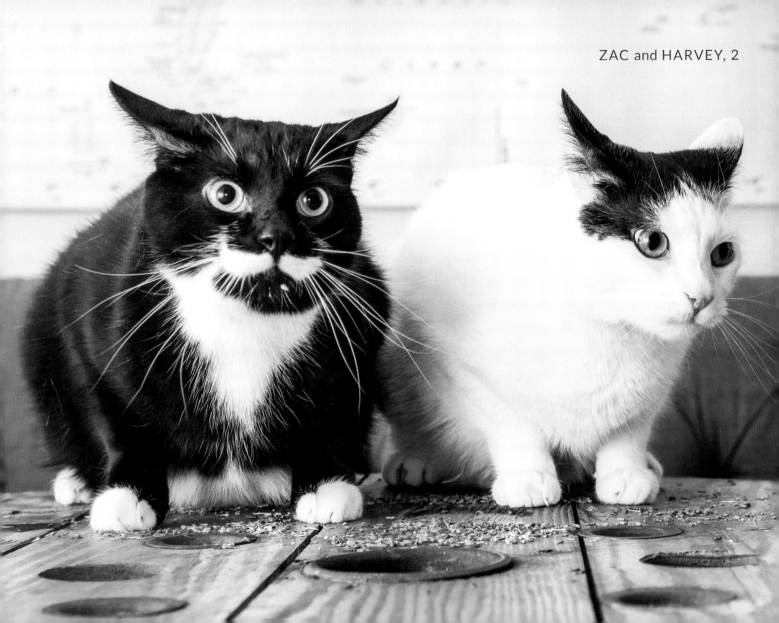

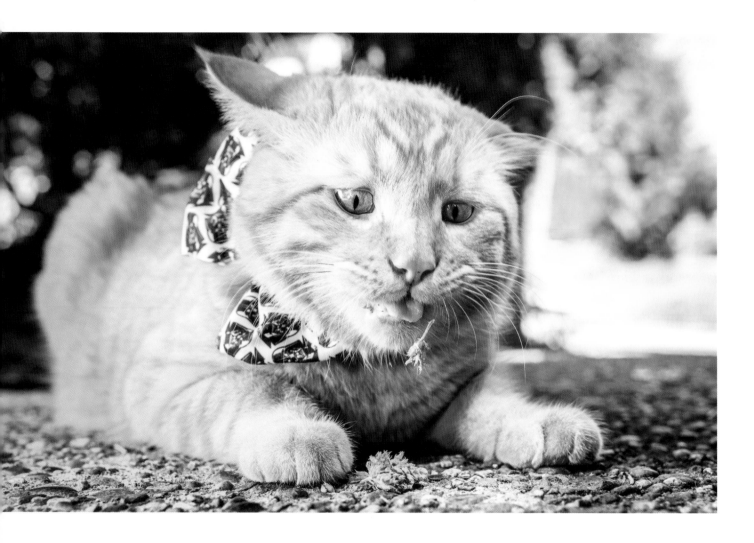

BENBEN, 2

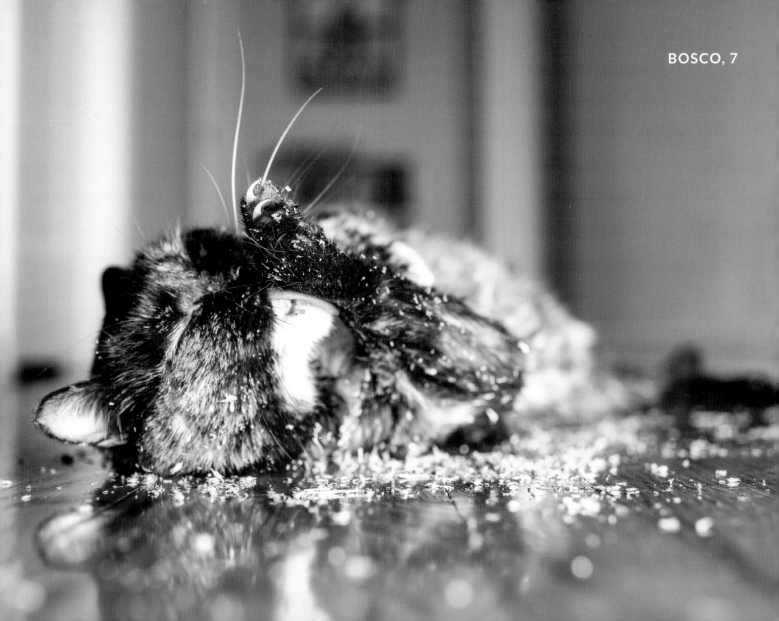

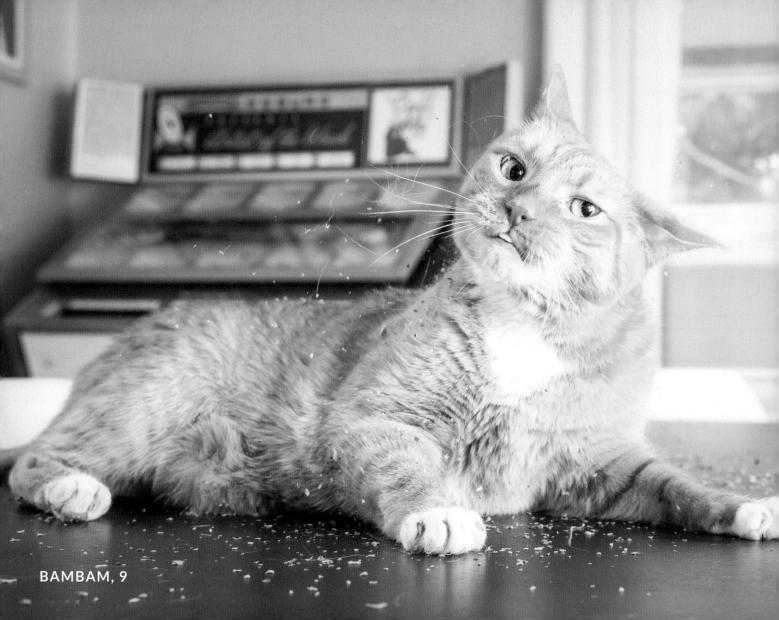

BAMBAM, 9

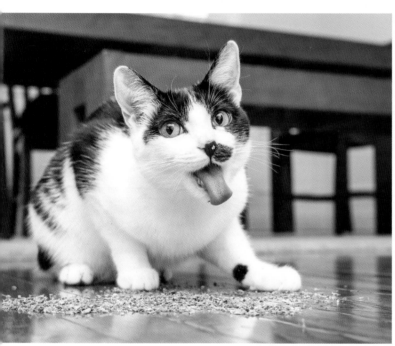
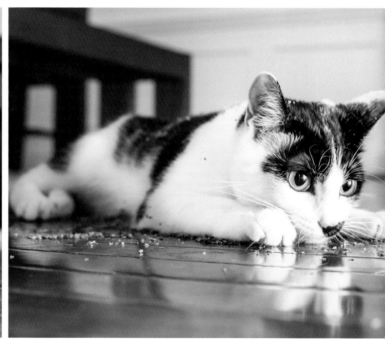

BANJO, 1

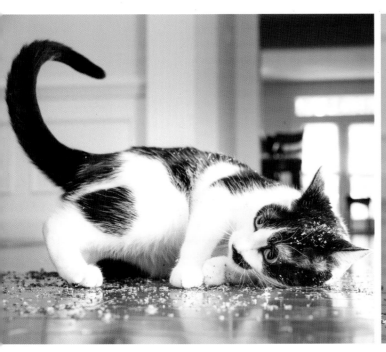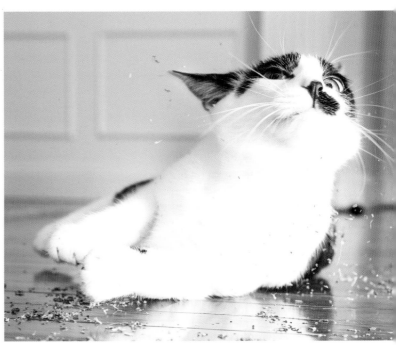

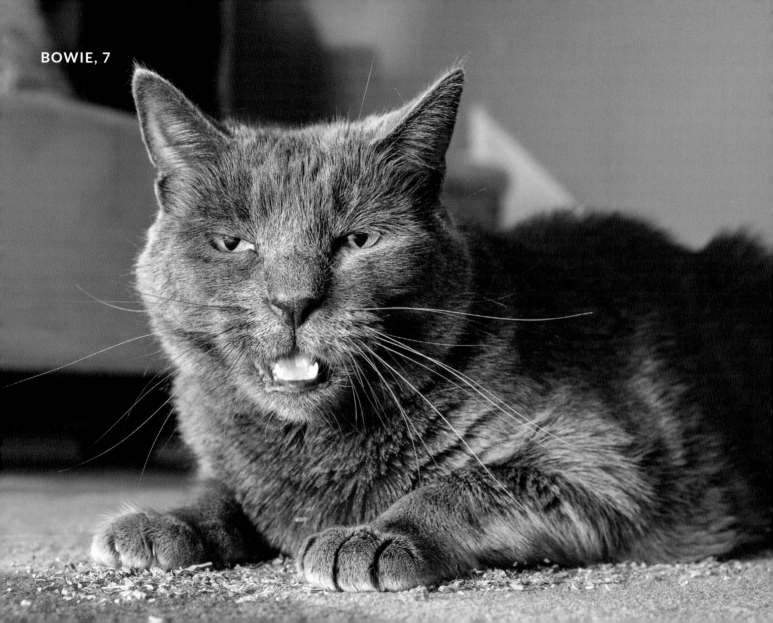

BOWIE, 7

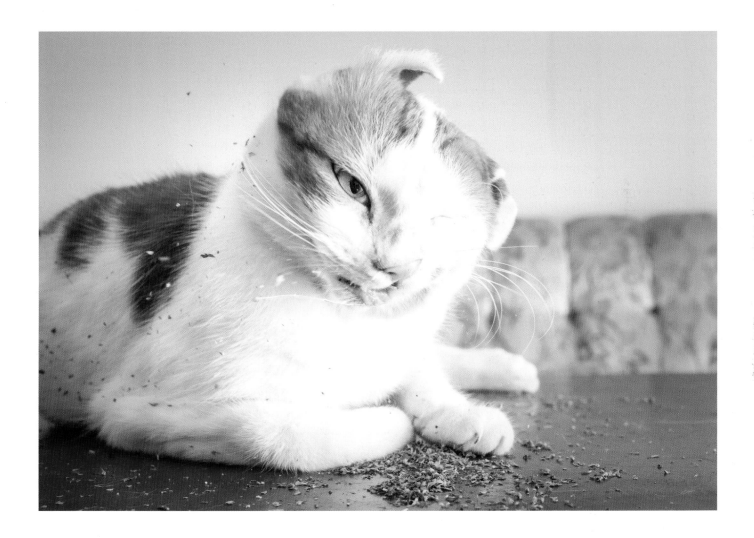

SASHA, 7

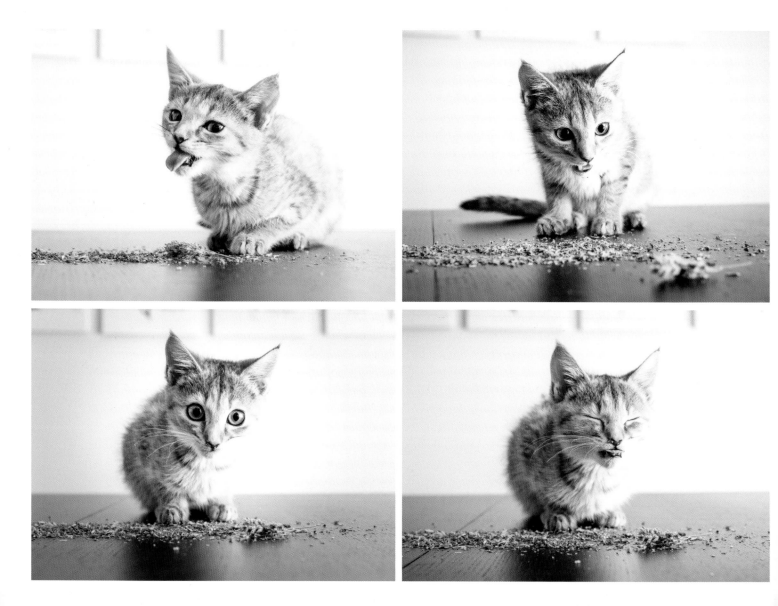

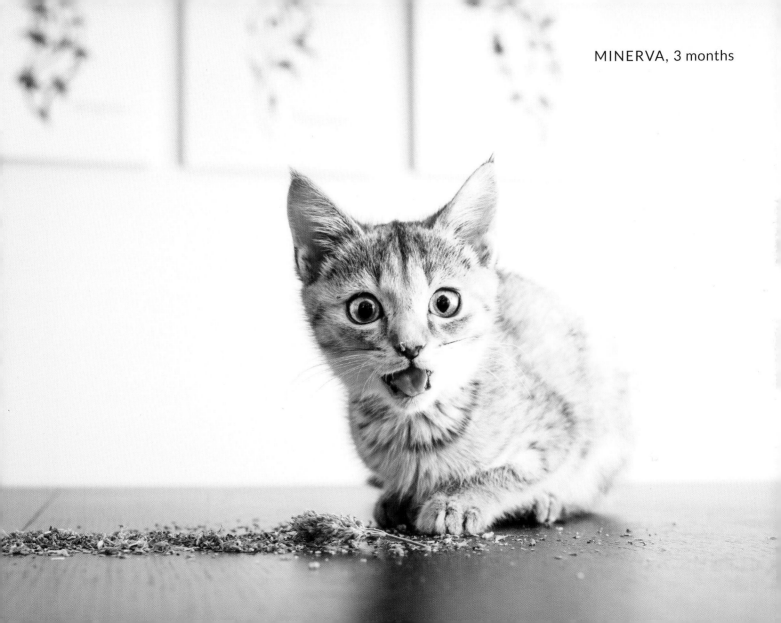

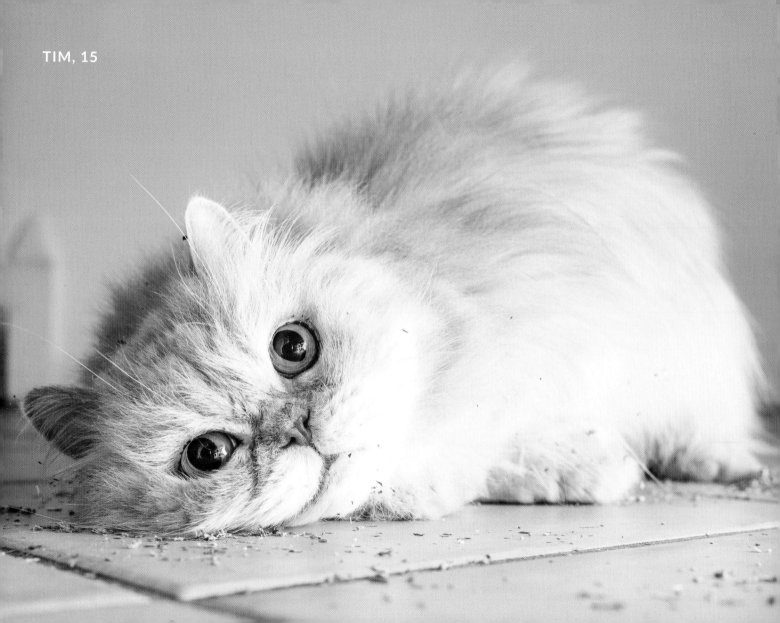

TIM, 15

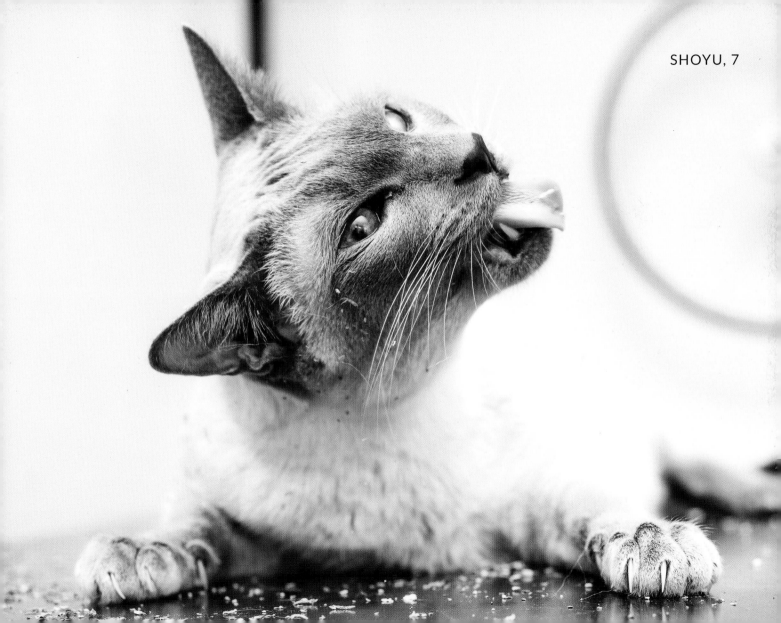

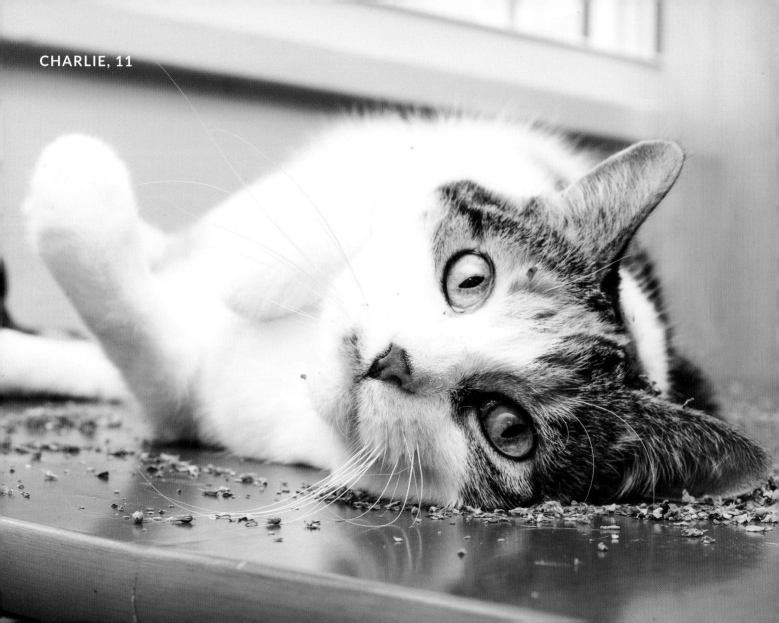

CHARLIE, 11

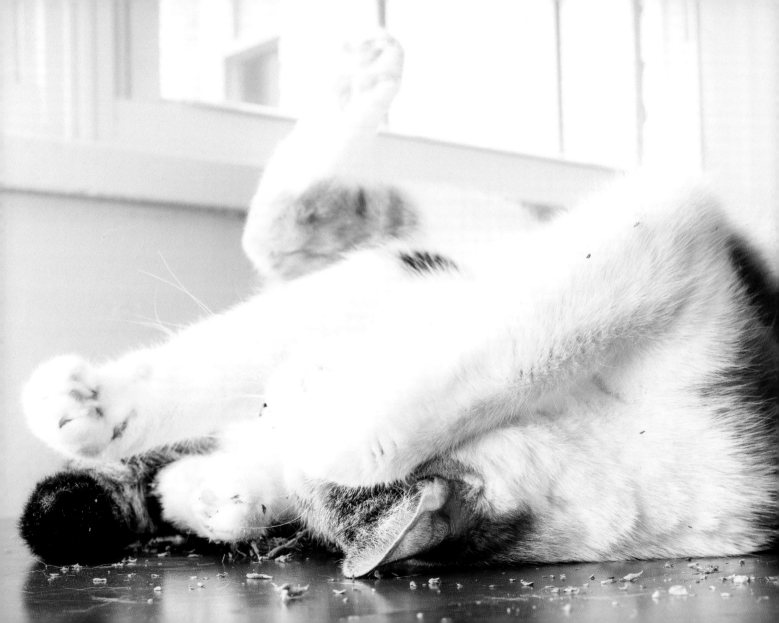

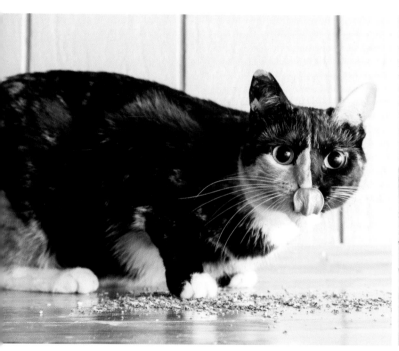
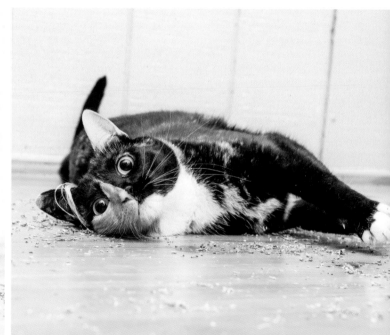

AURELIUS, 4

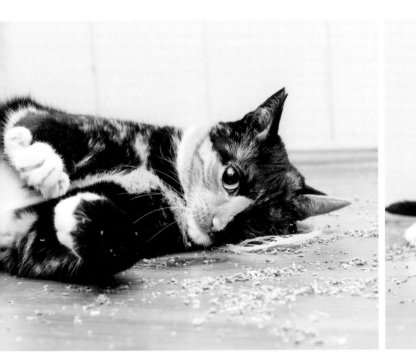
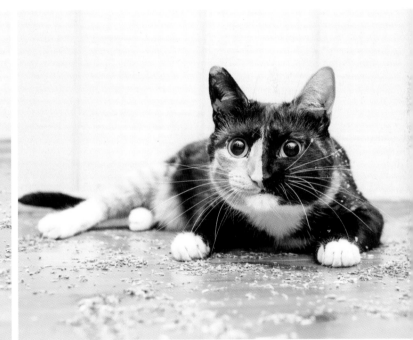

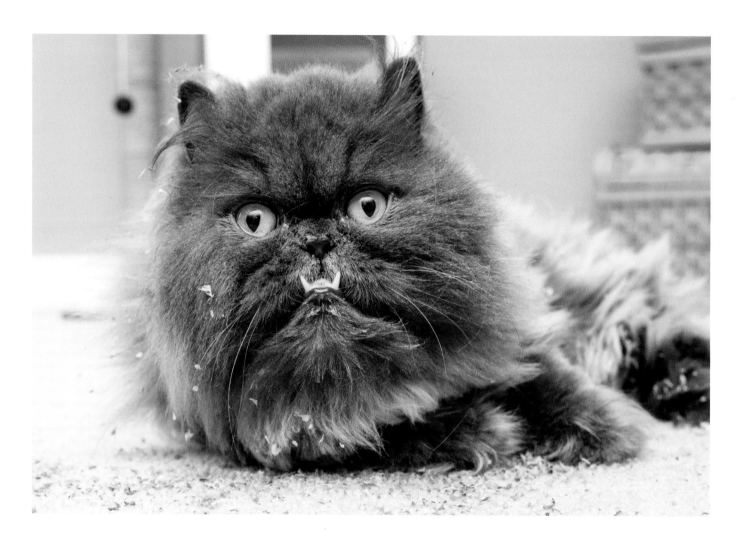

MISS RASPBERRY, 4

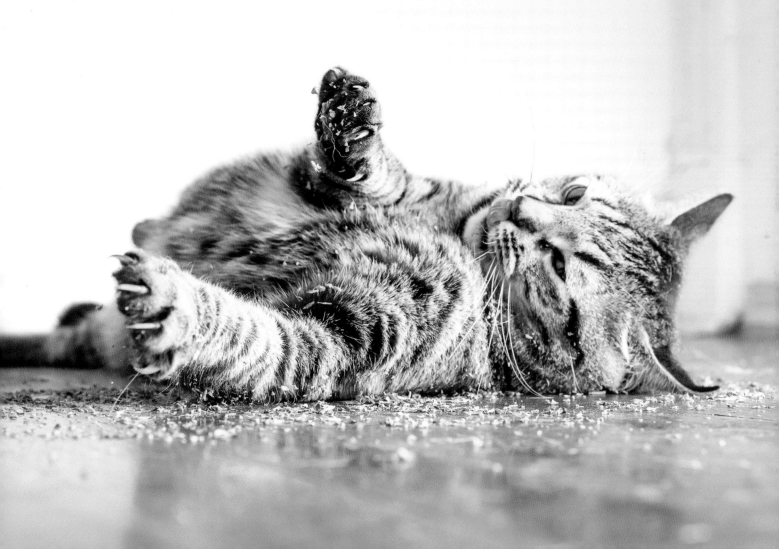

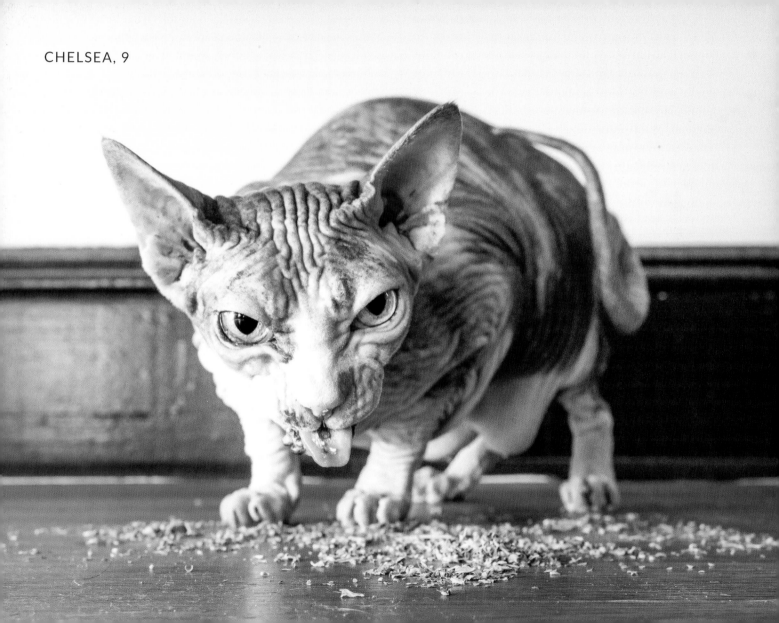

CHELSEA, 9

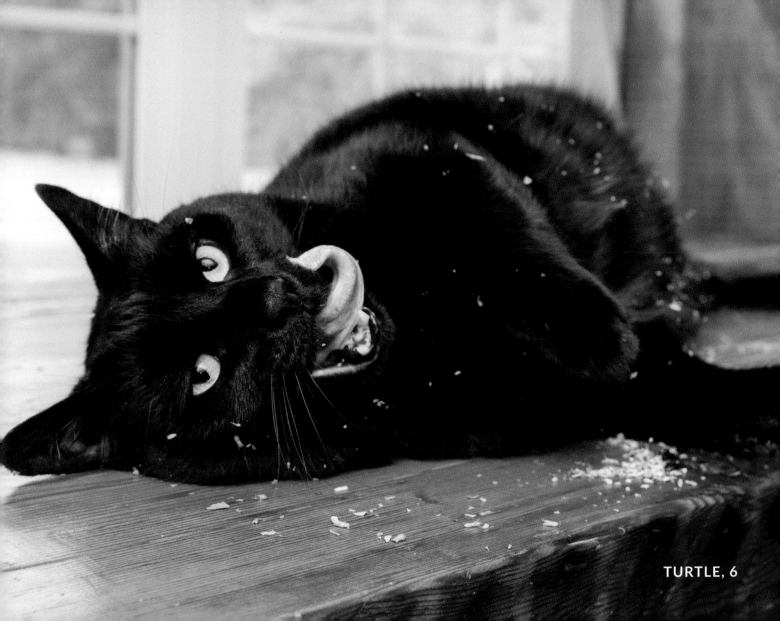

TURTLE, 6

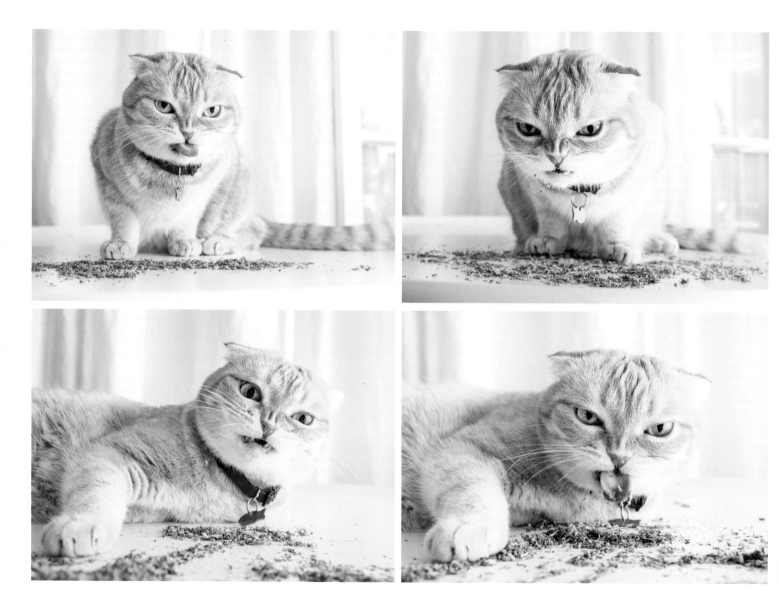

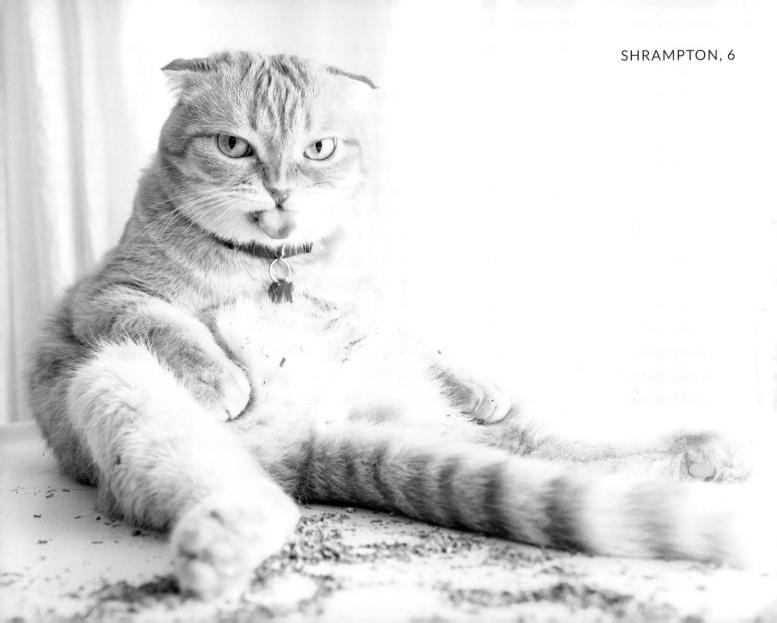

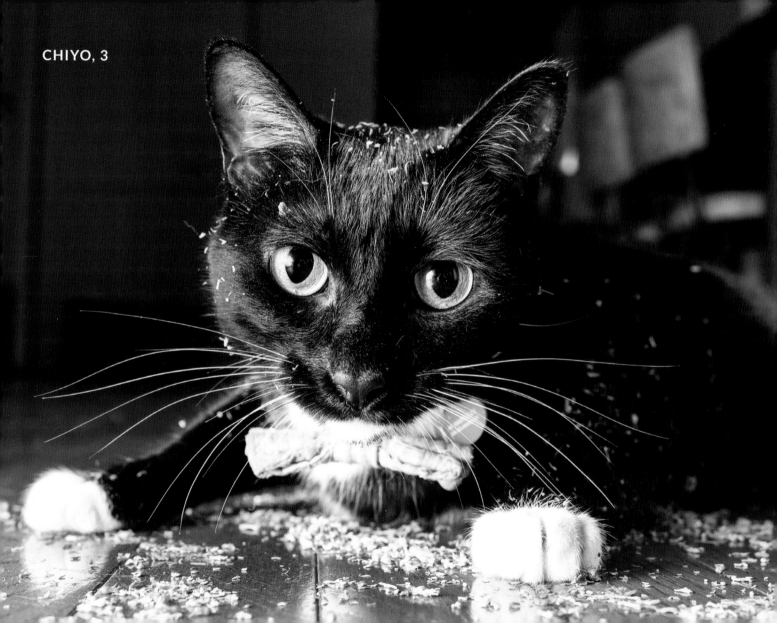

CHIYO, 3

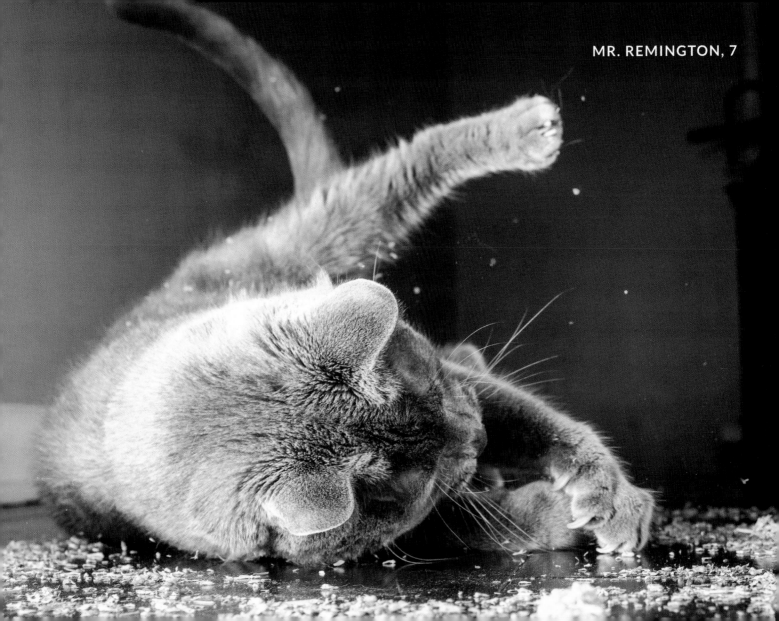

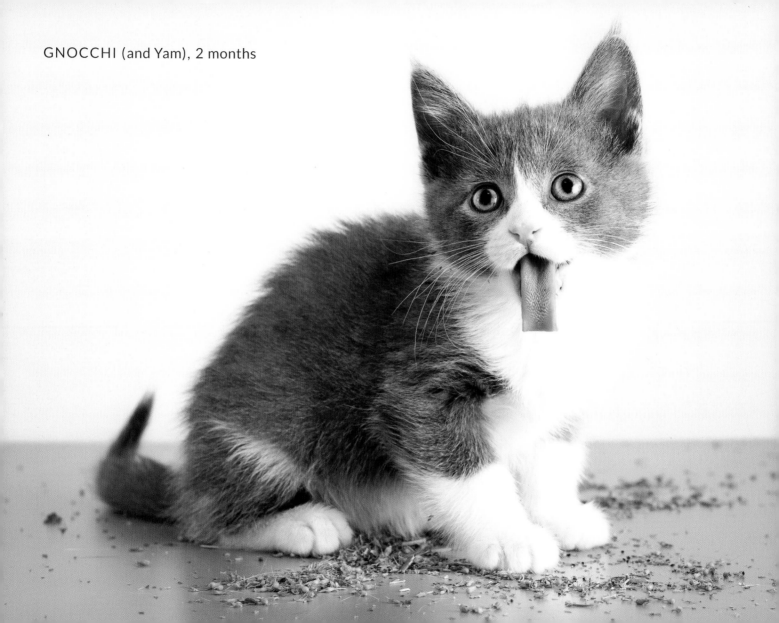

GNOCCHI (and Yam), 2 months

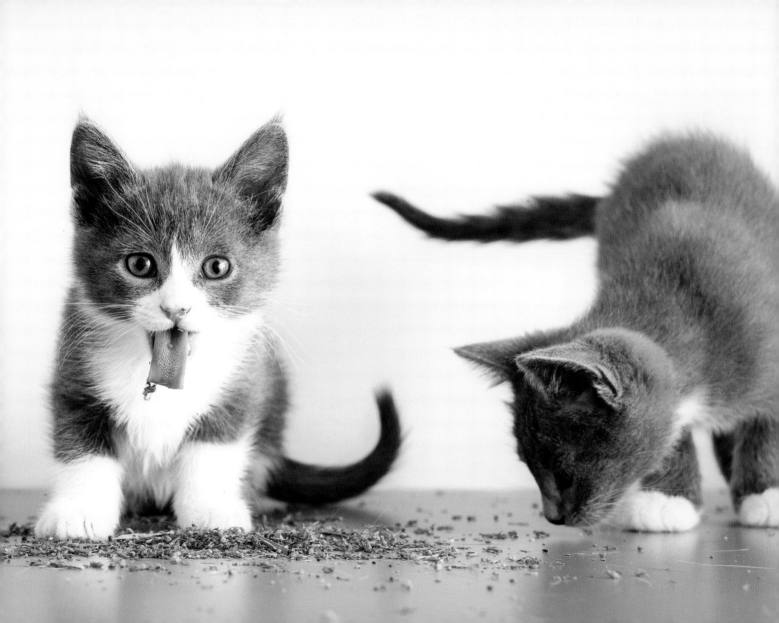

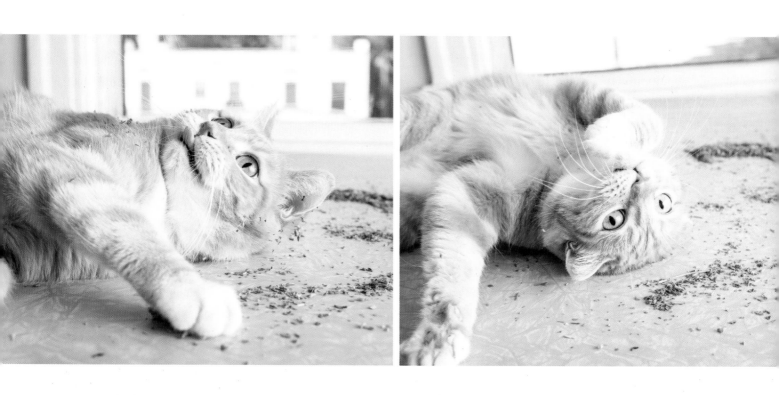

FIN (and Sawyer), 7

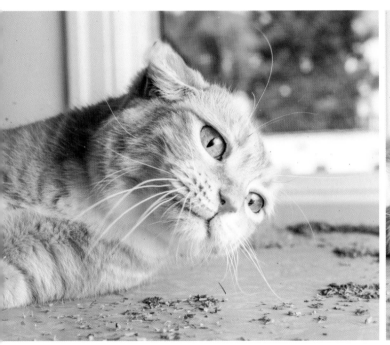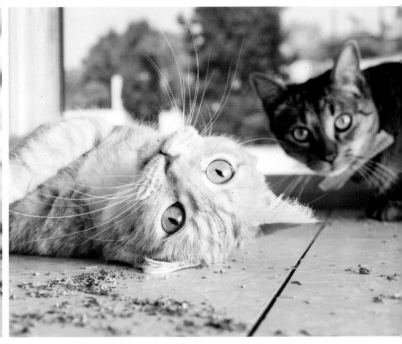

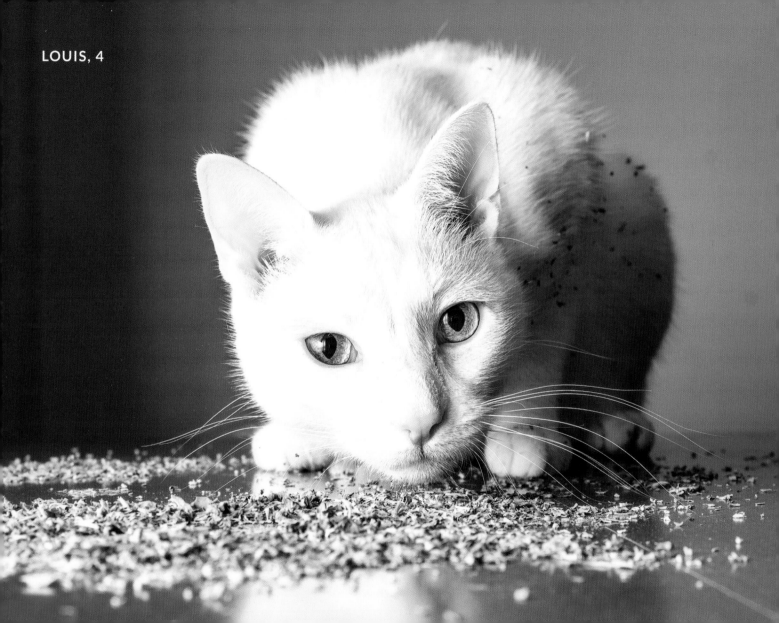

LOUIS, 4

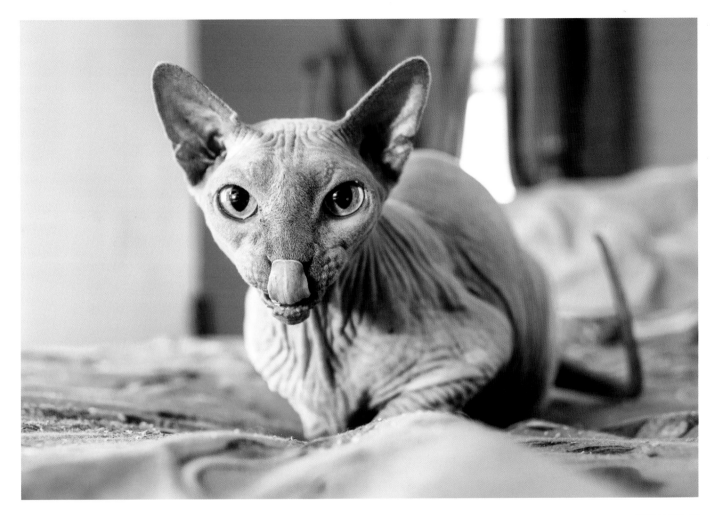

PINKY, 7

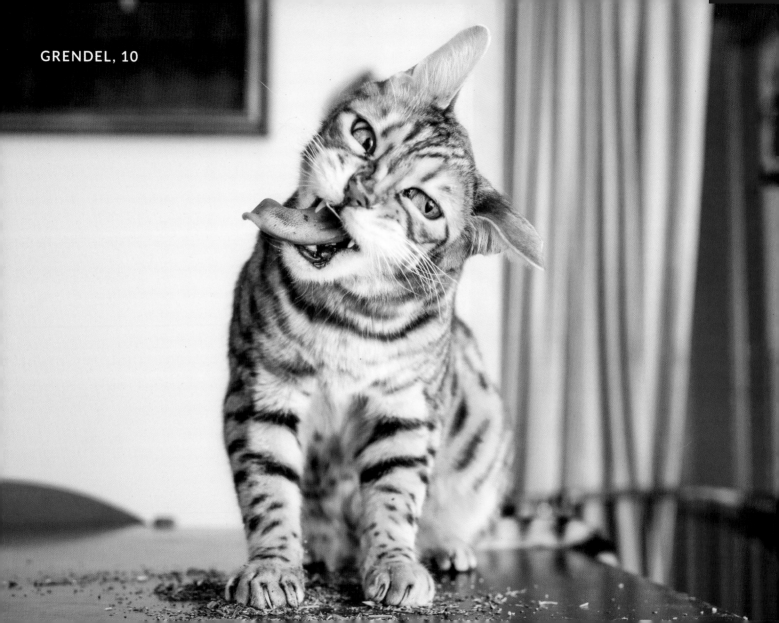

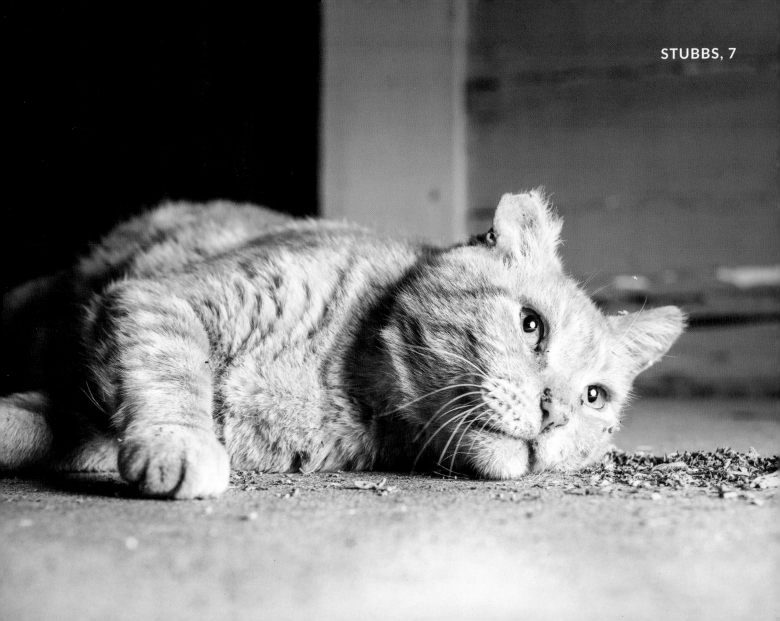

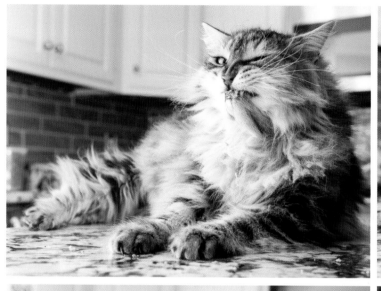
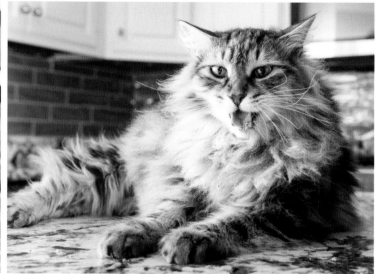
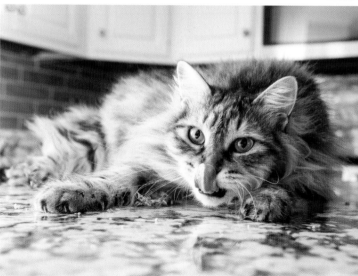
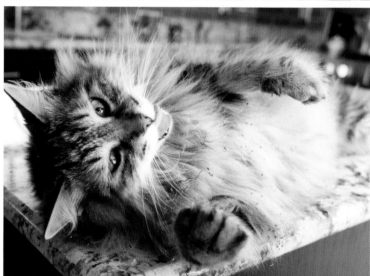

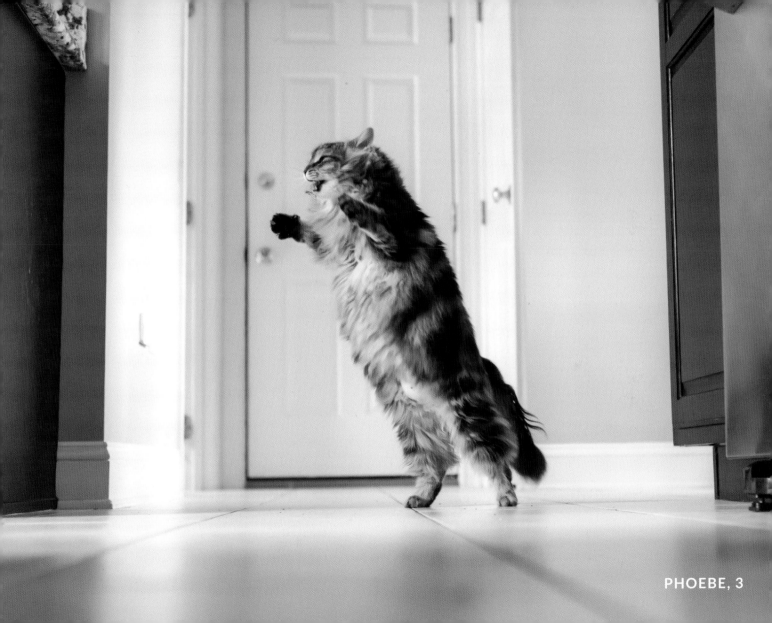

PHOEBE, 3

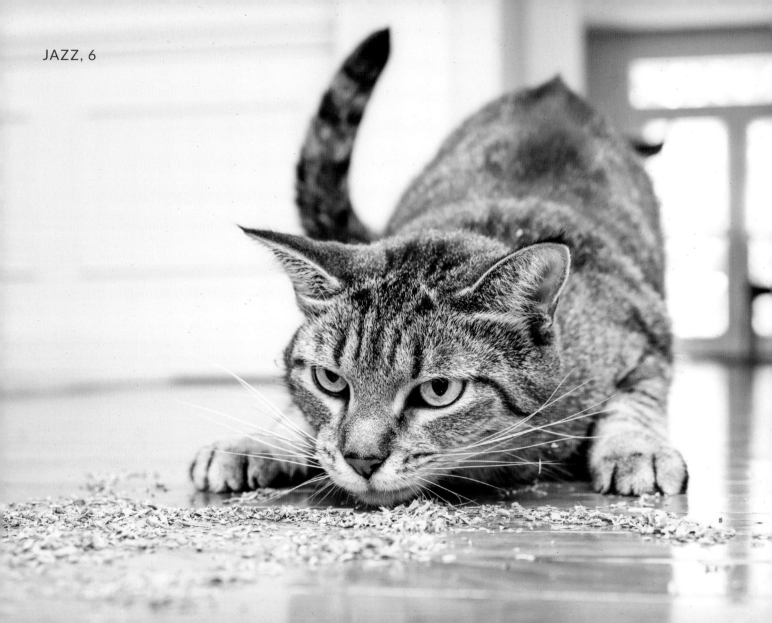

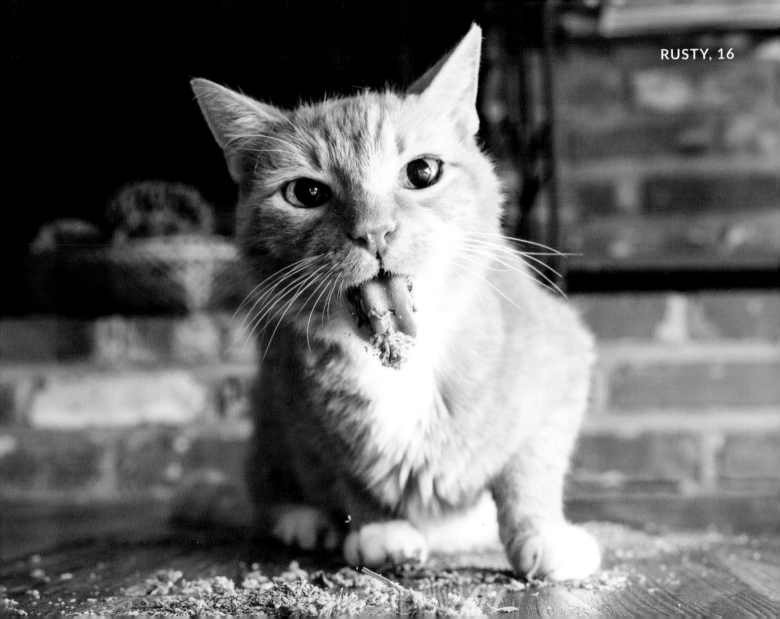

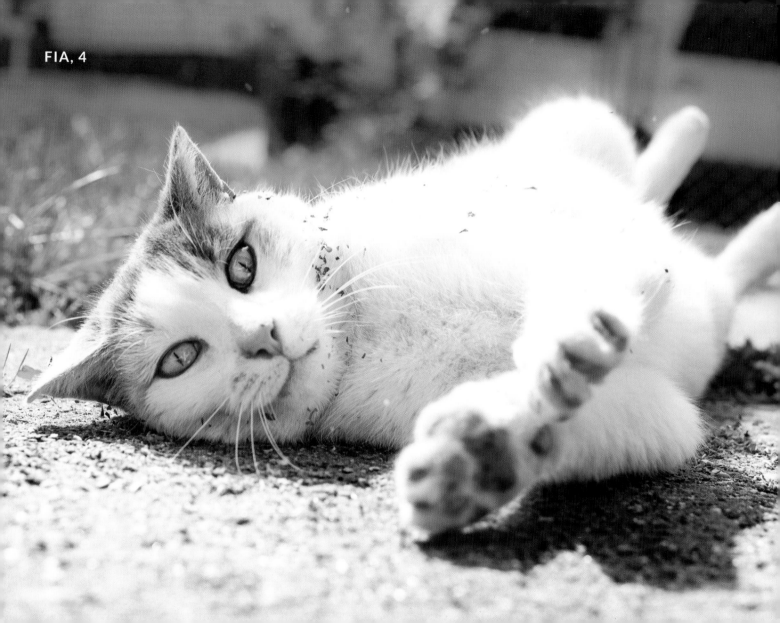

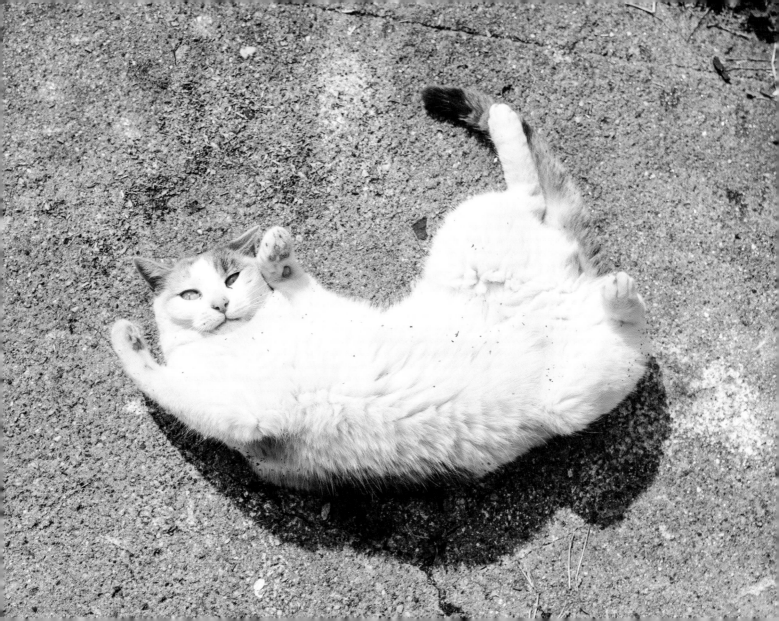

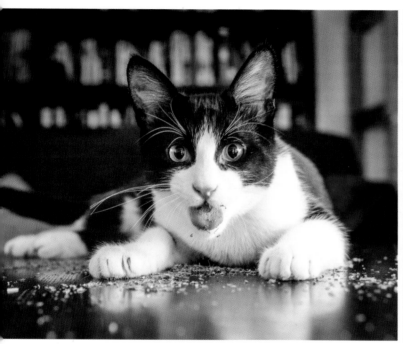 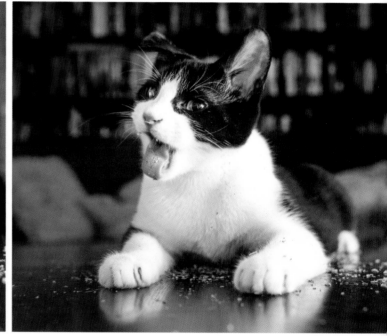

GOBLIN, 6 months

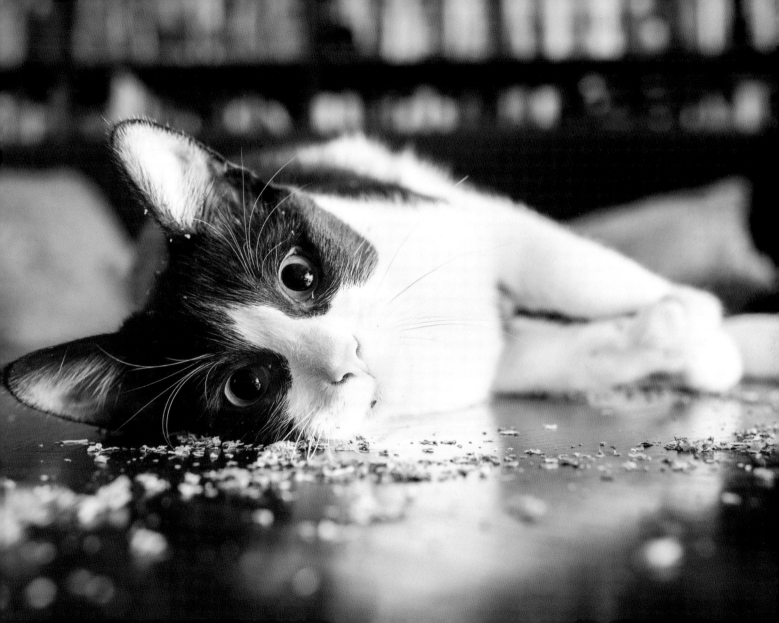

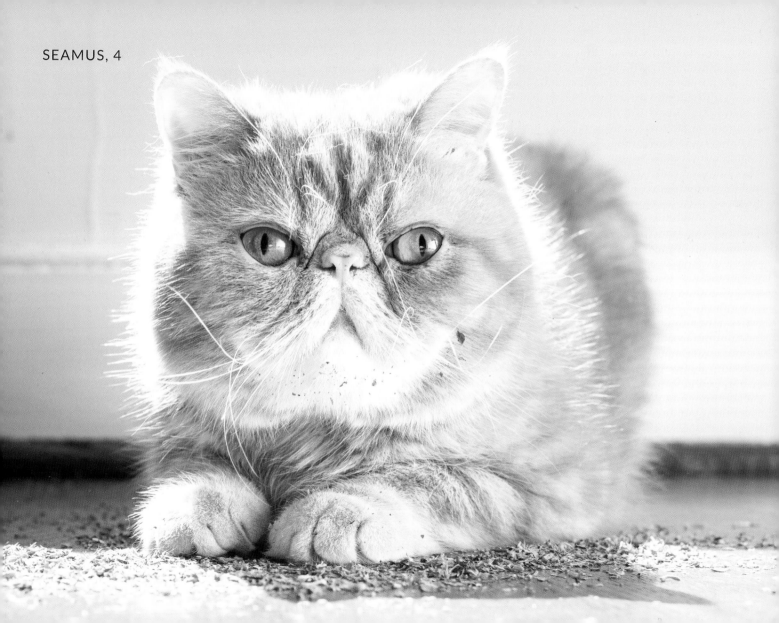

SEAMUS, 4

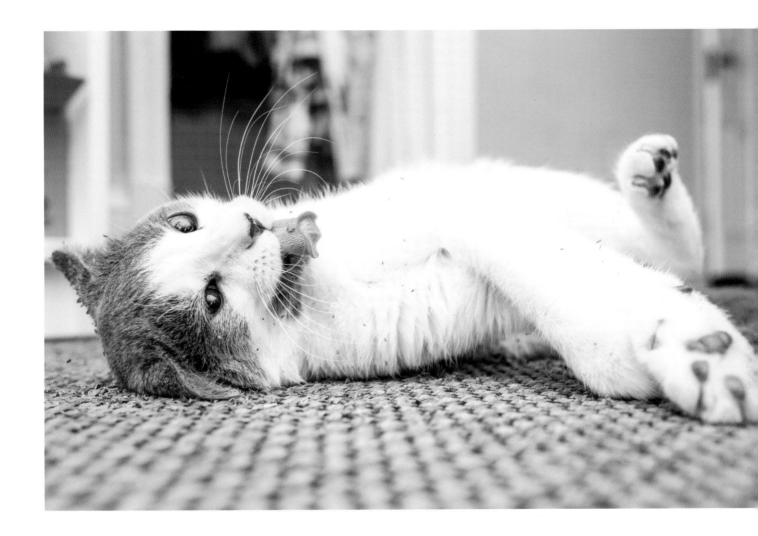

TIDBIT, 1

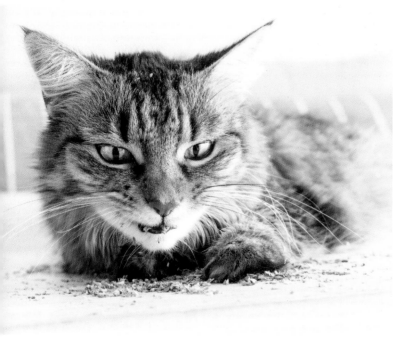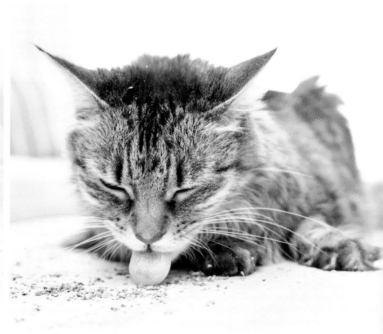

FOXY, 9

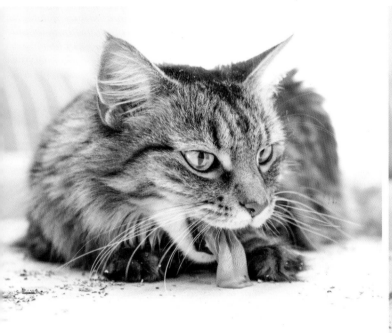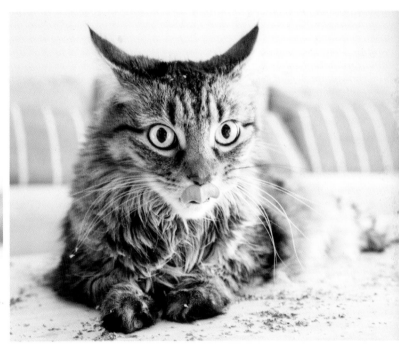

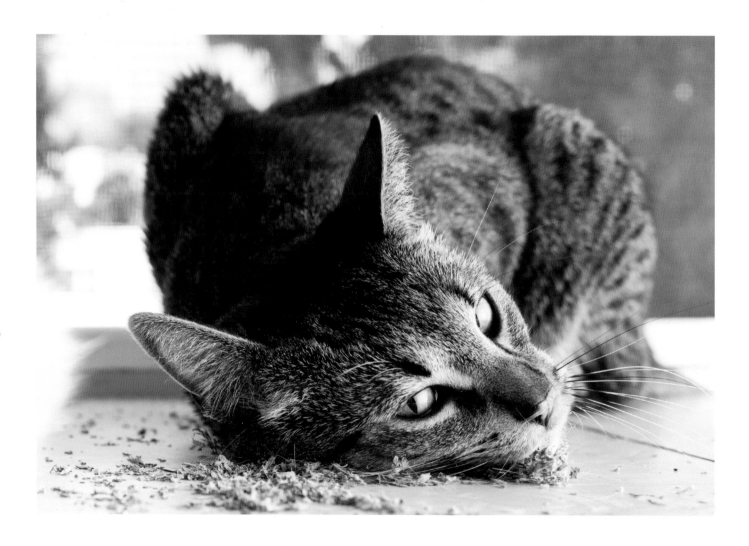

SAWYER, 4

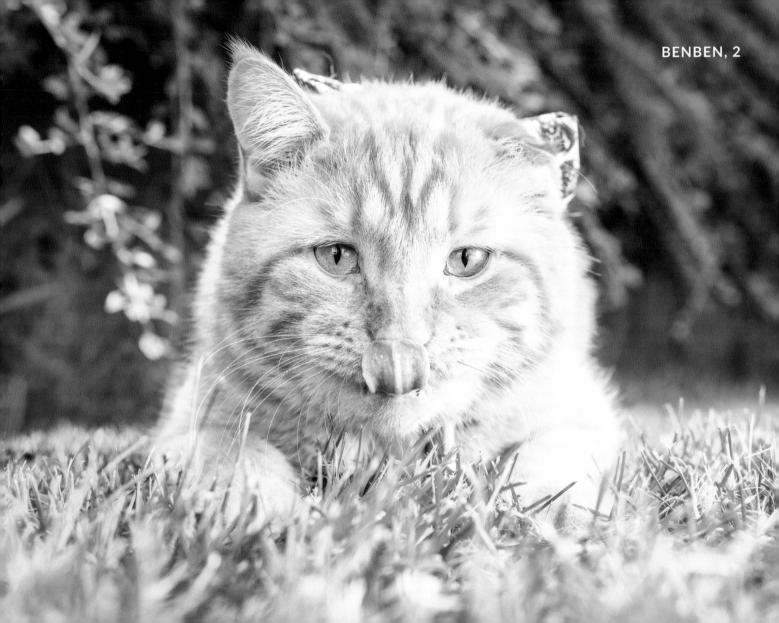

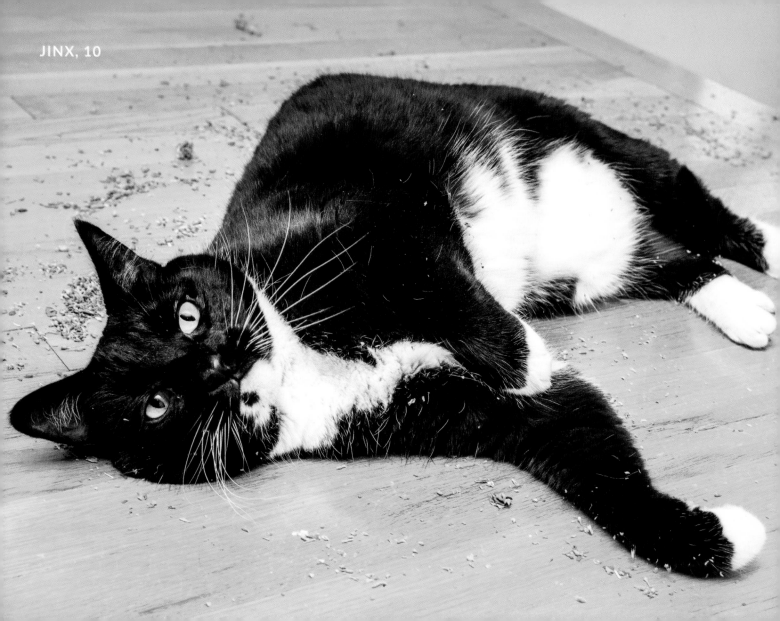

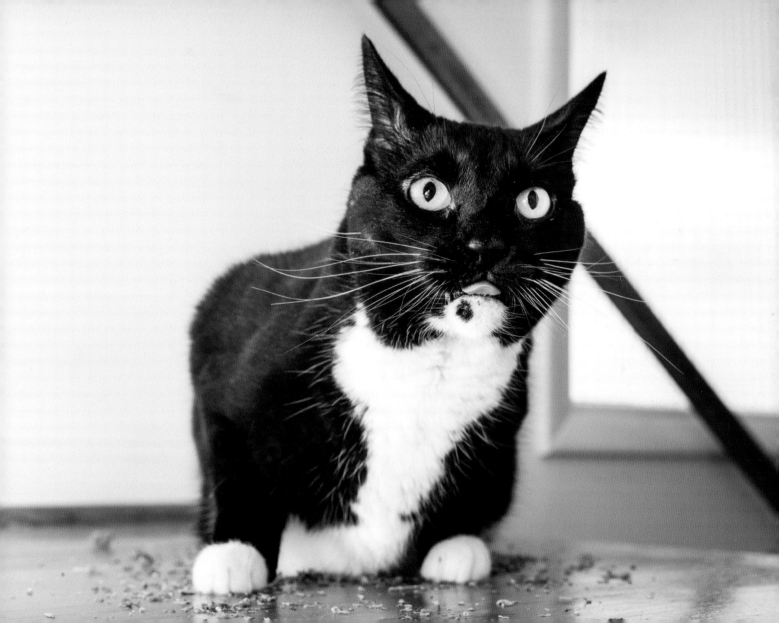

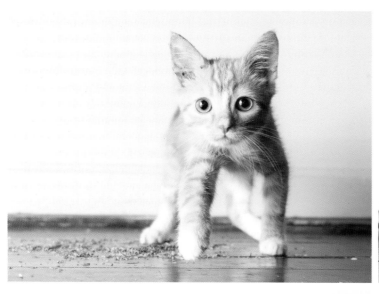
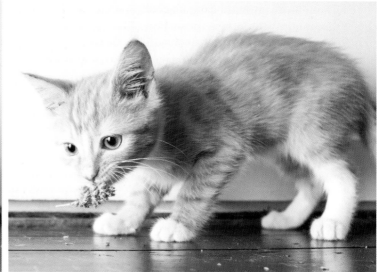
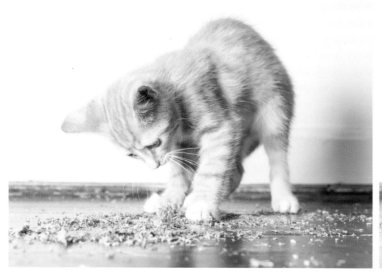
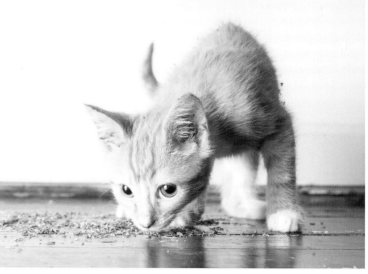

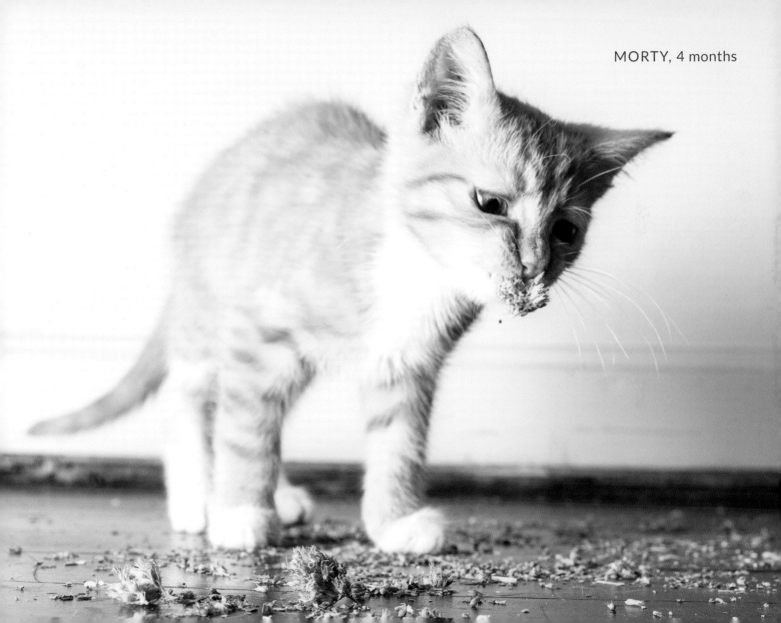

MORTY, 4 months

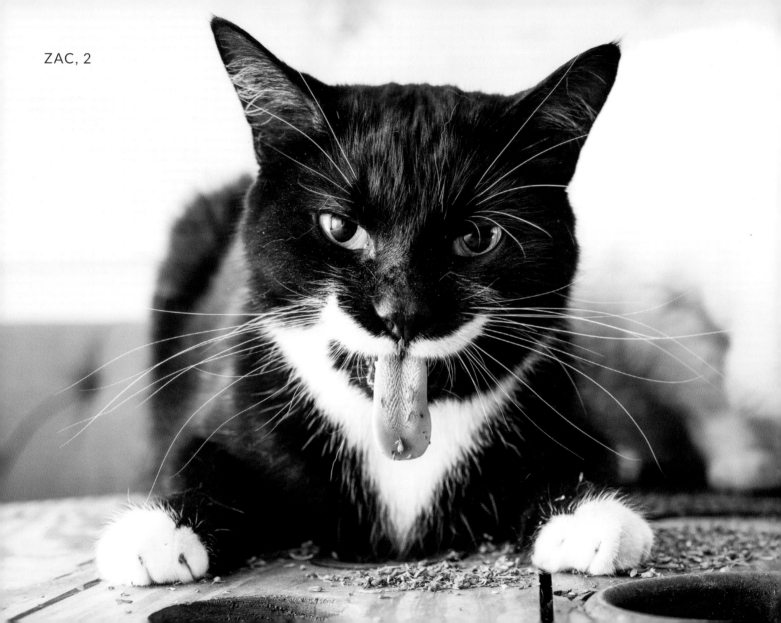

ZAC, 2

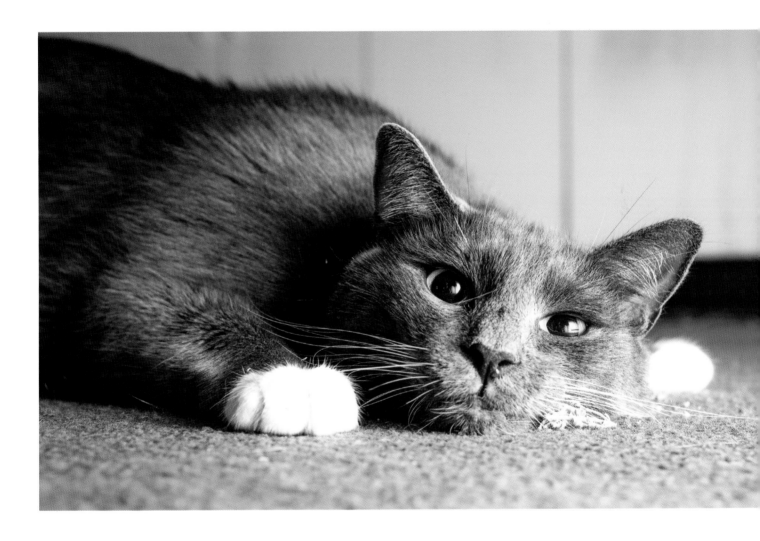

PETER, 3

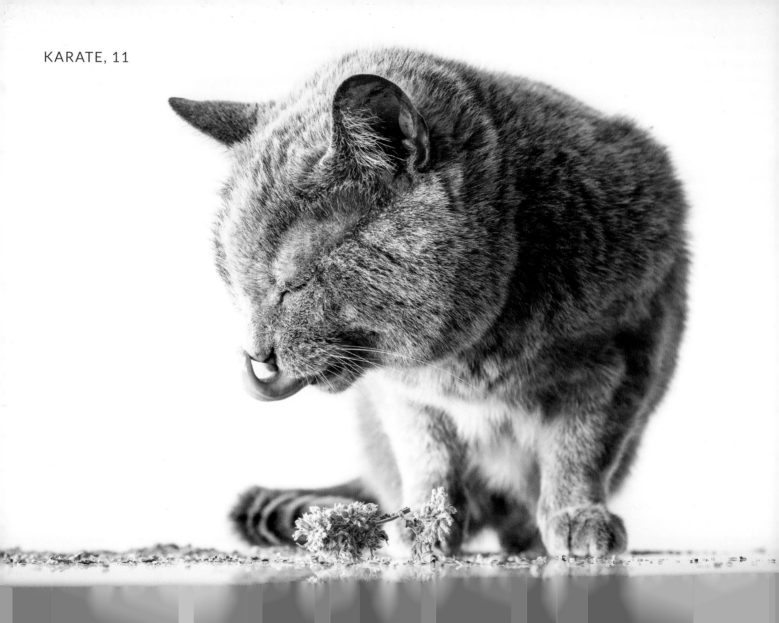

KARATE, 11

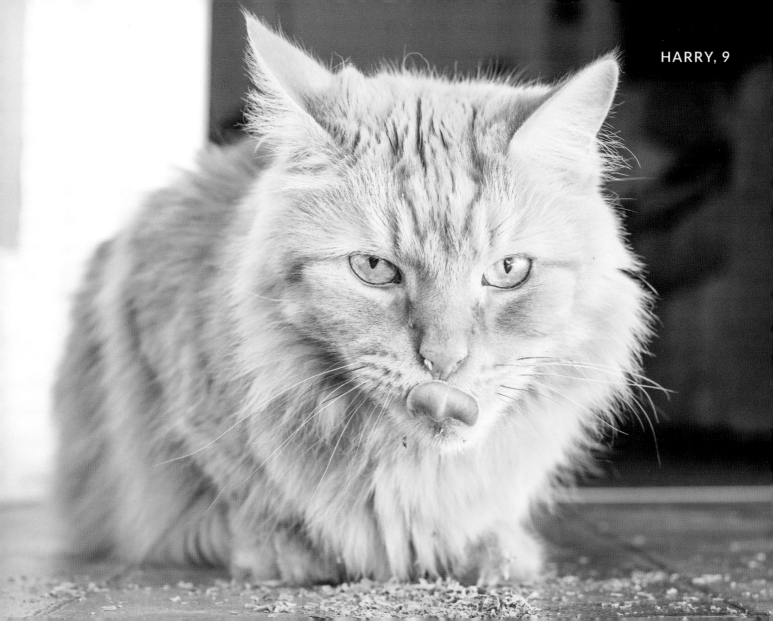

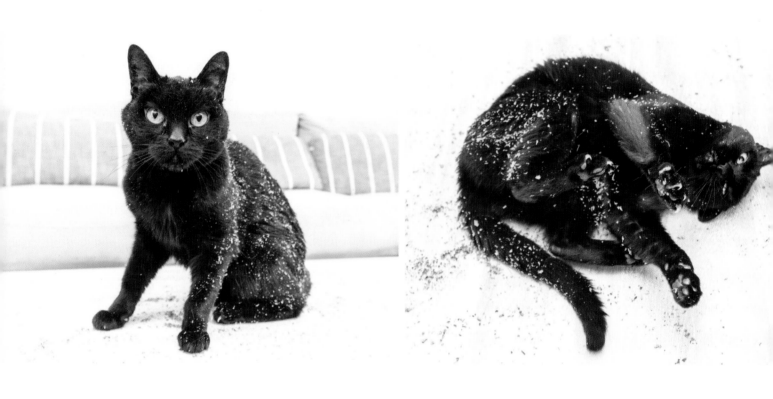

FACE (and Foxy), 15

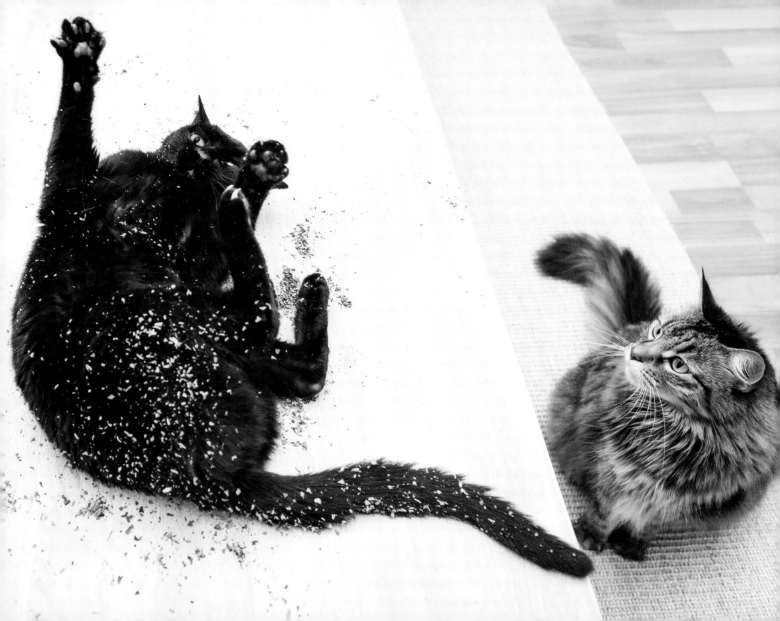

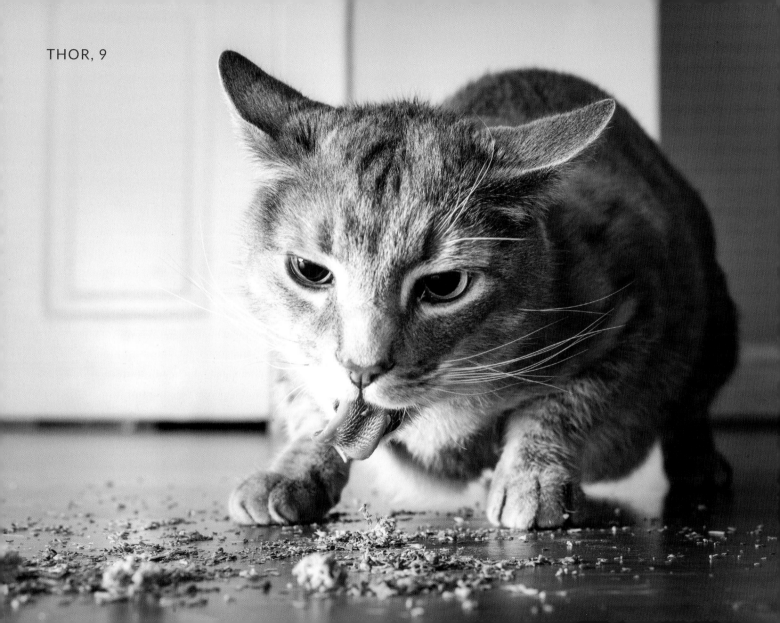

THOR, 9

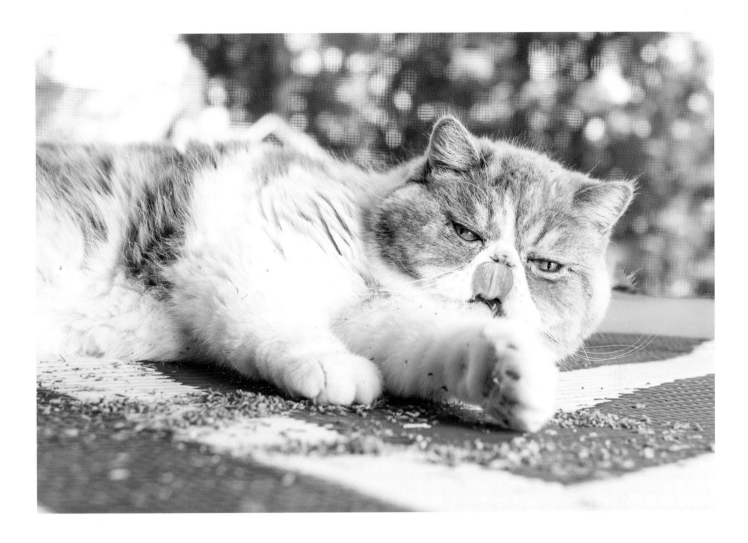

BETTY, 4

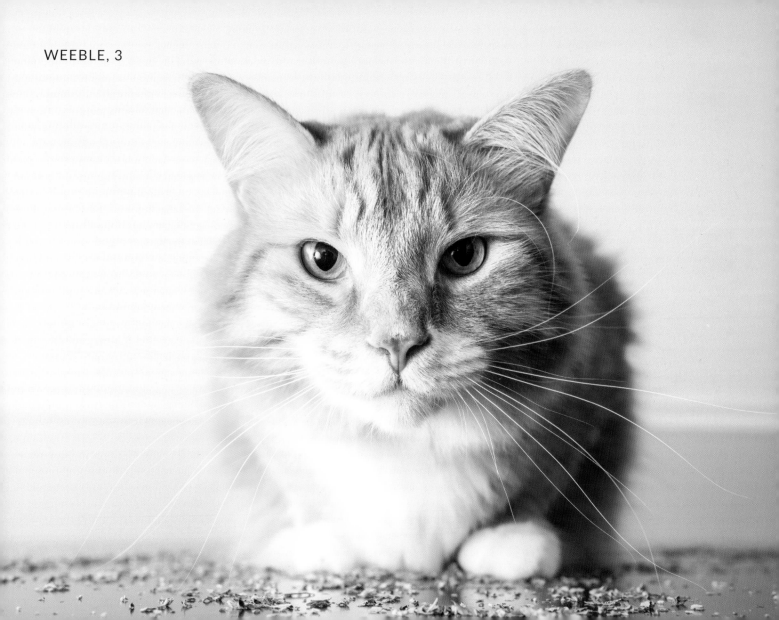
WEEBLE, 3

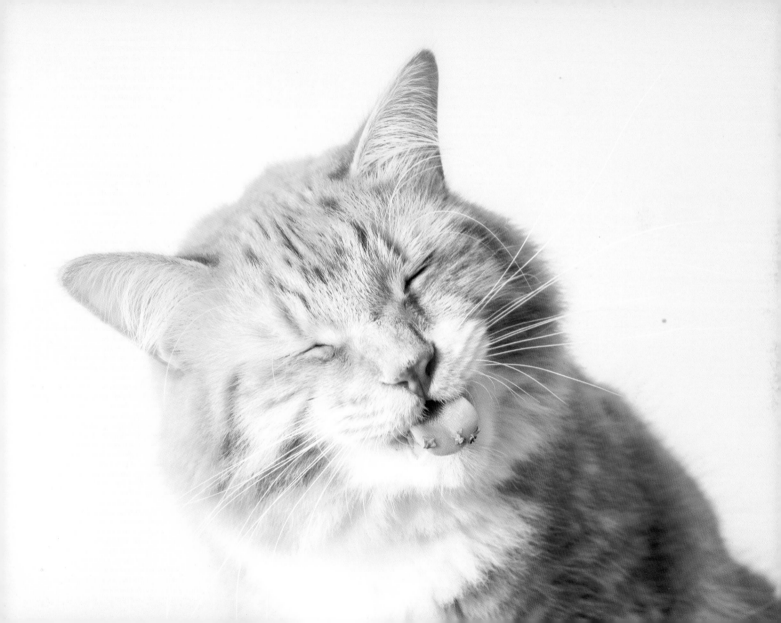

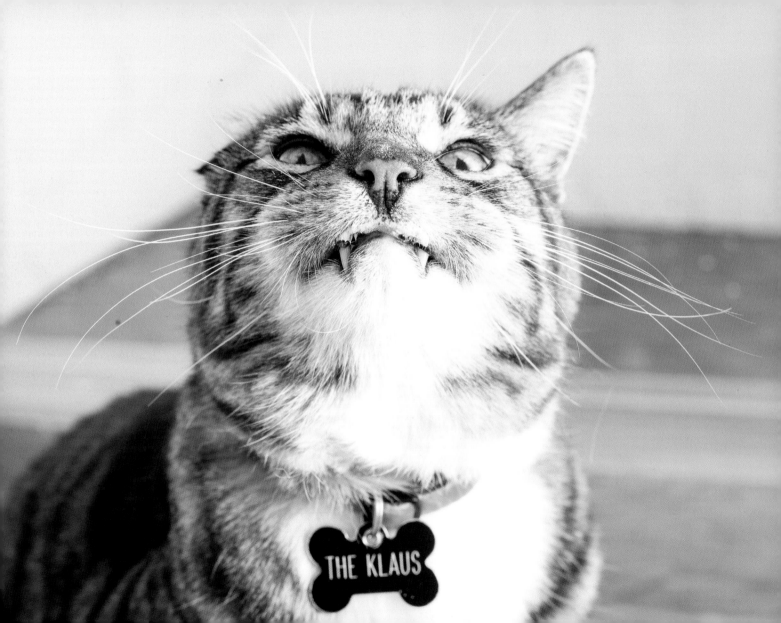

THE KLAUS

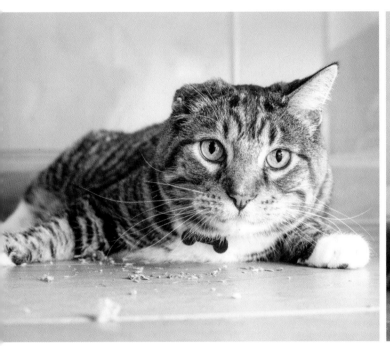 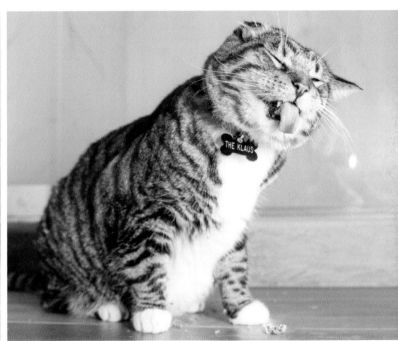

KLAUS, 16

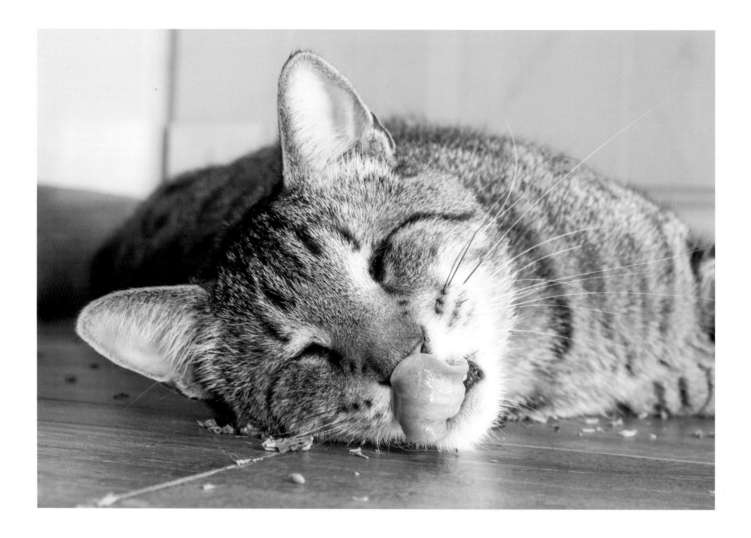

OSKAR, 6

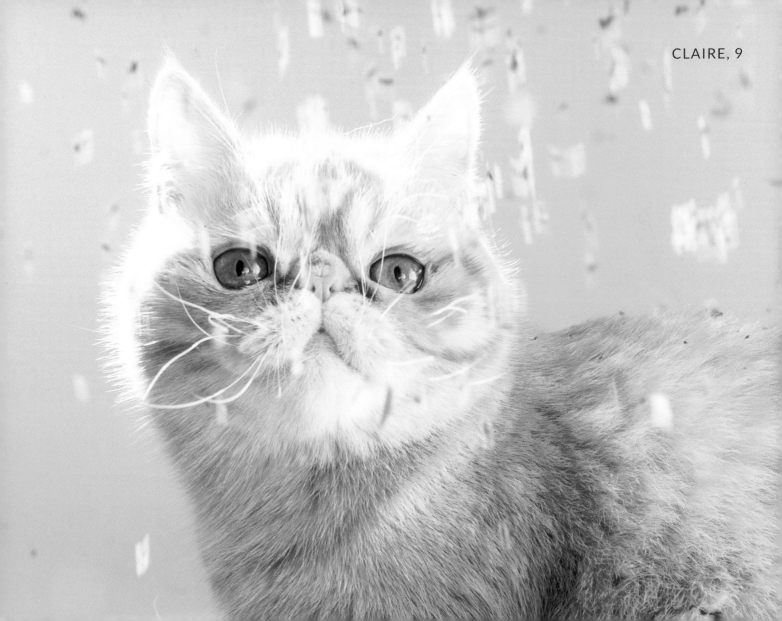

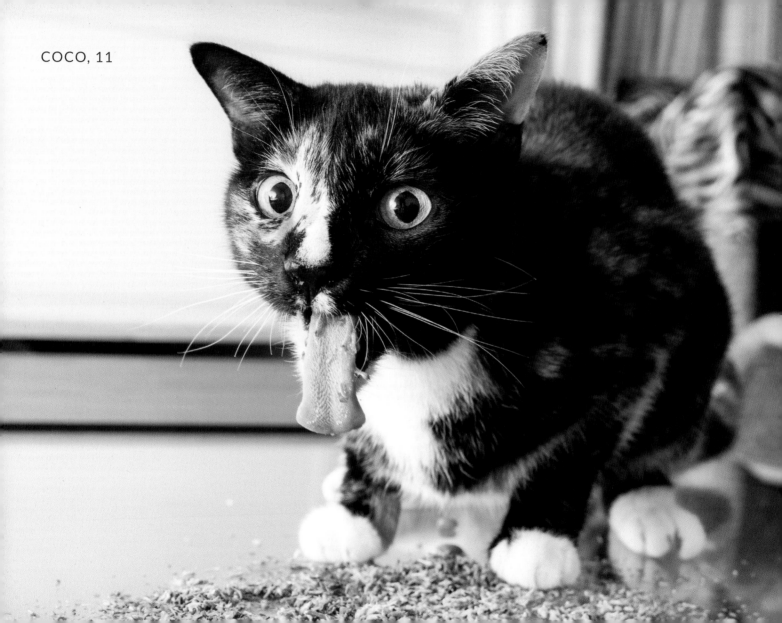

COCO, 11

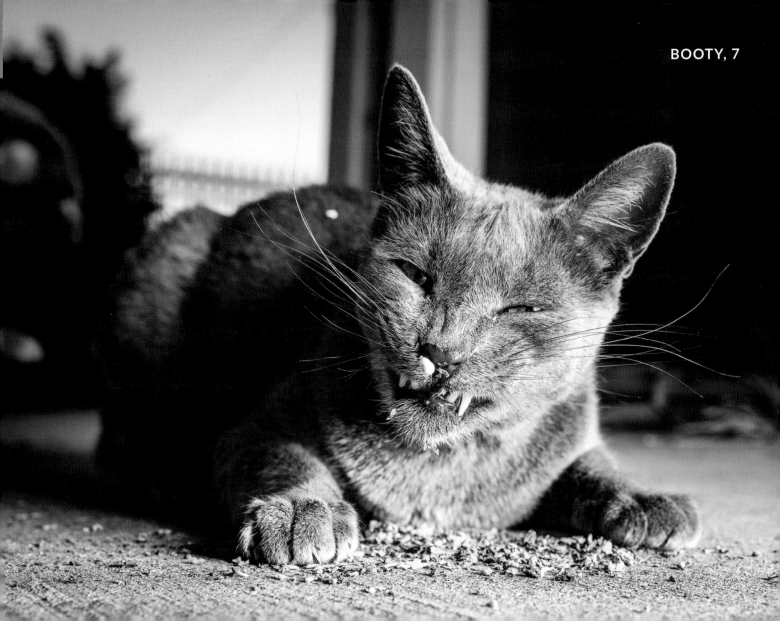

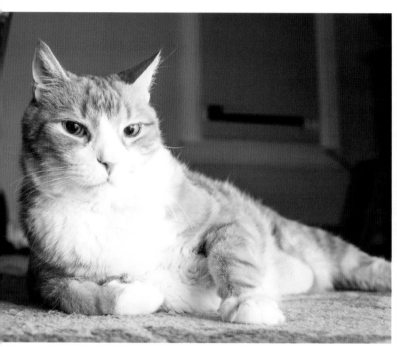 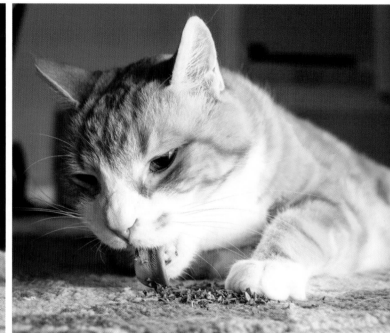

OLIVER TACO (and Simba), 11

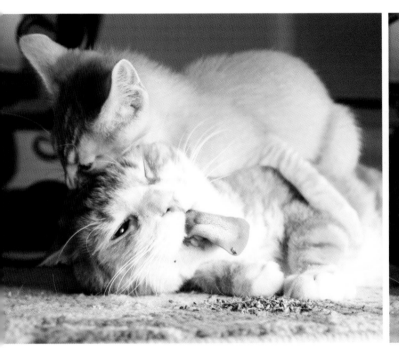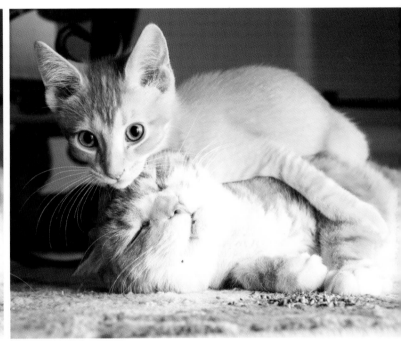

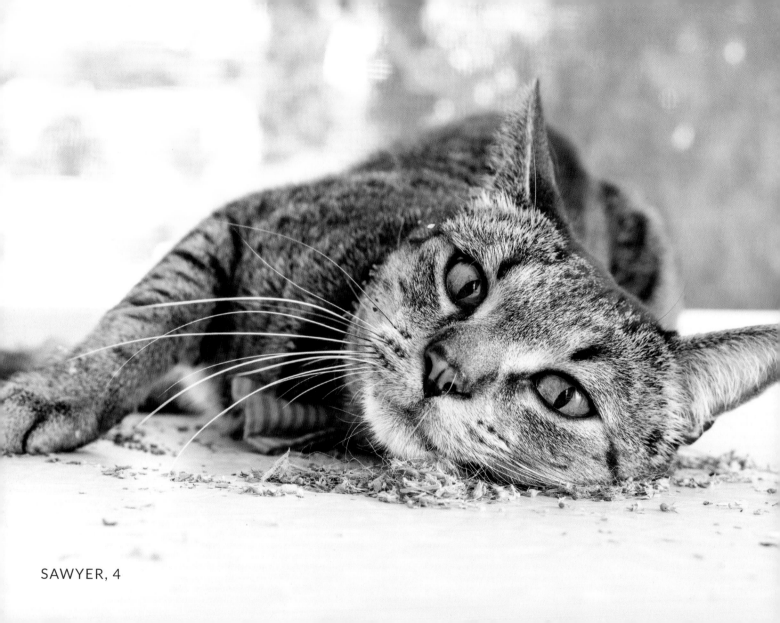

SAWYER, 4

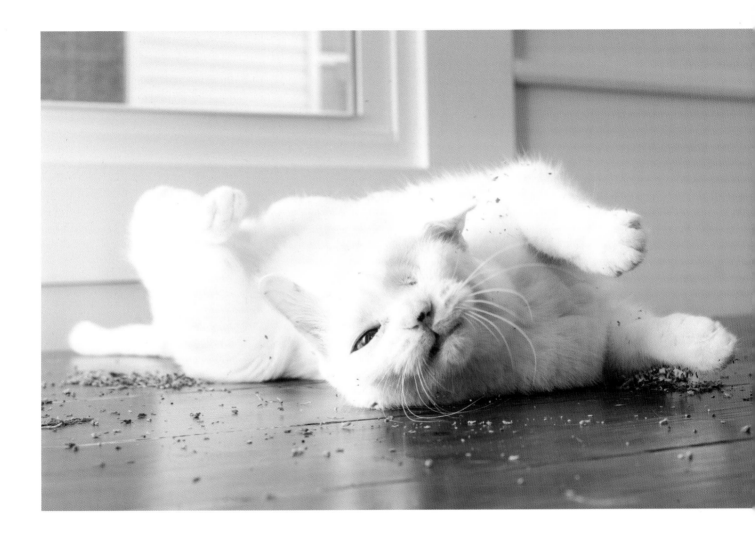

ELOISE, 5

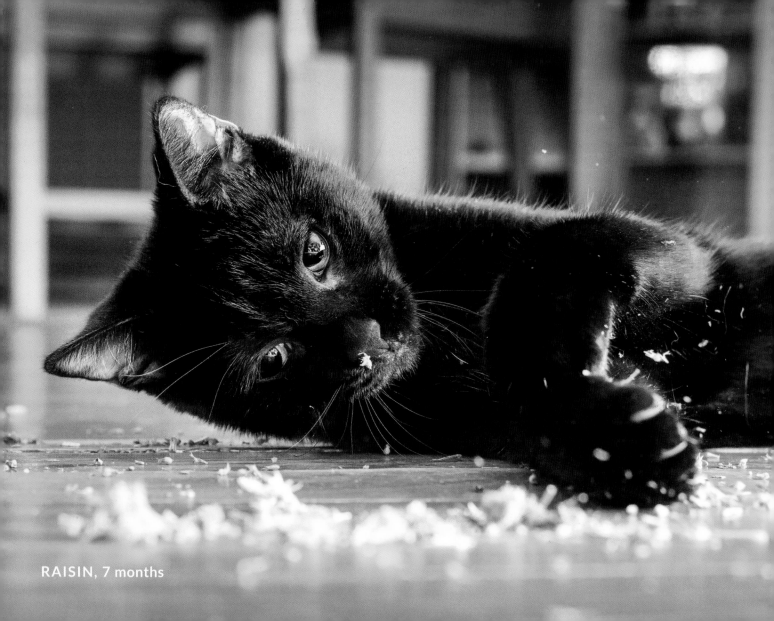

RAISIN, 7 months

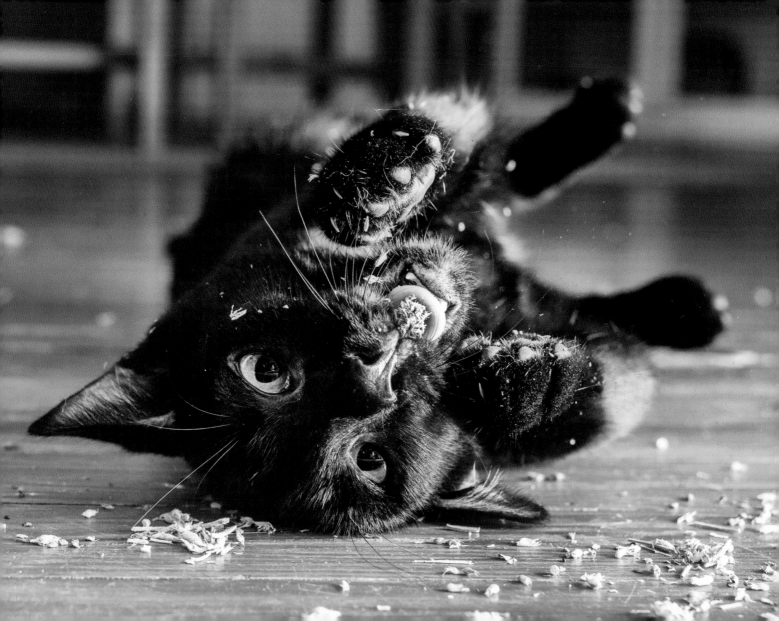

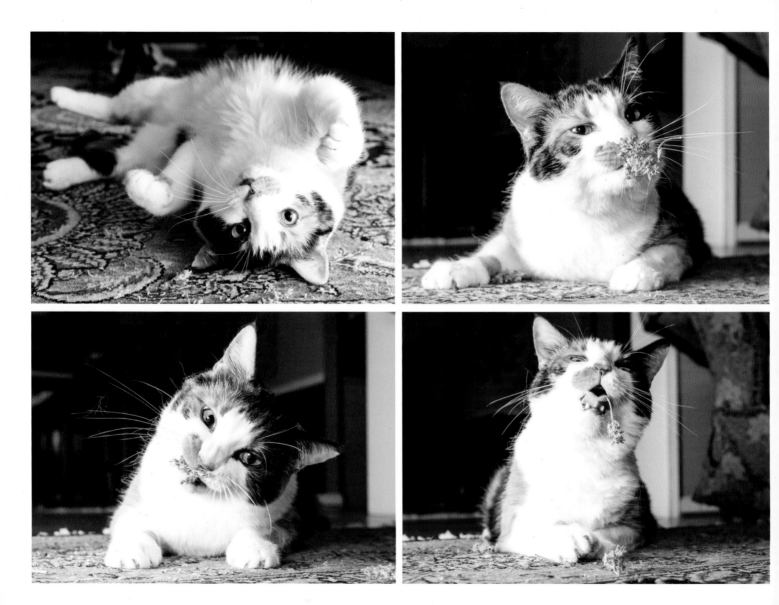

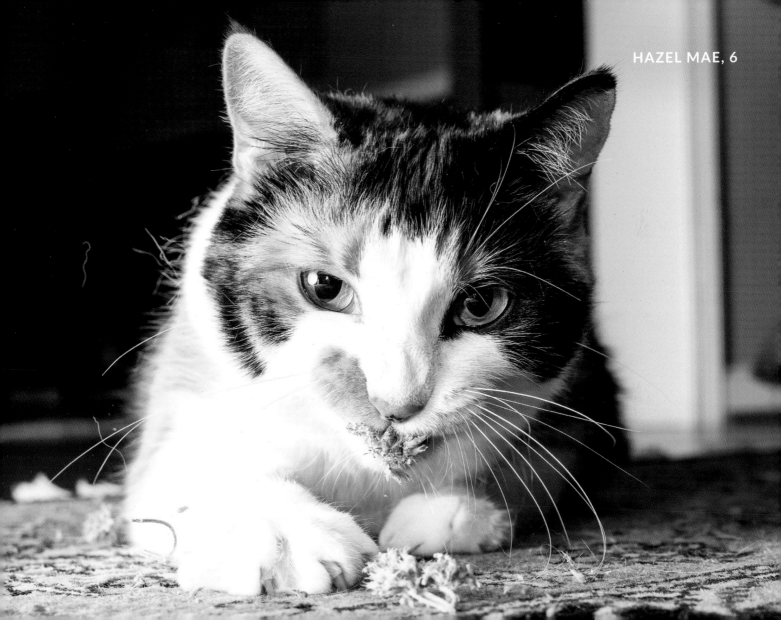

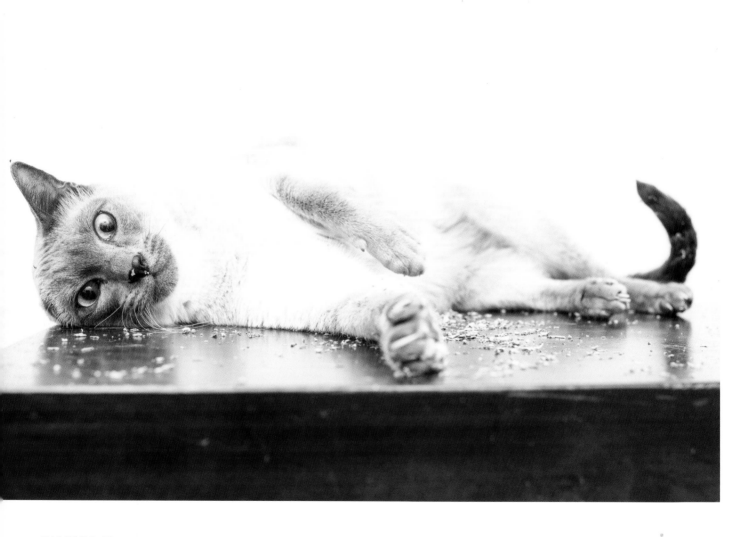

SHOYU, 7

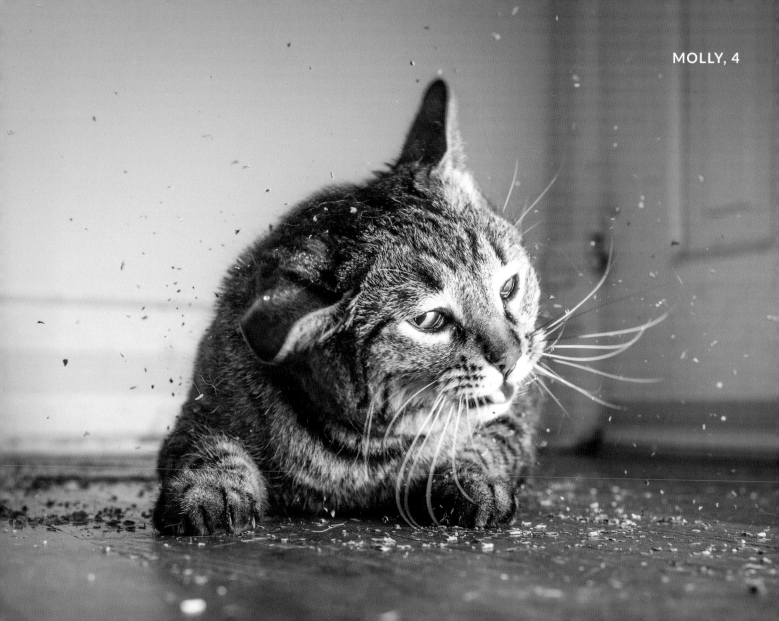

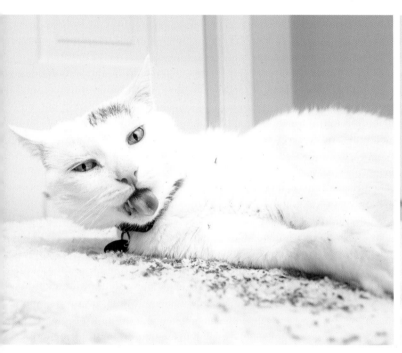
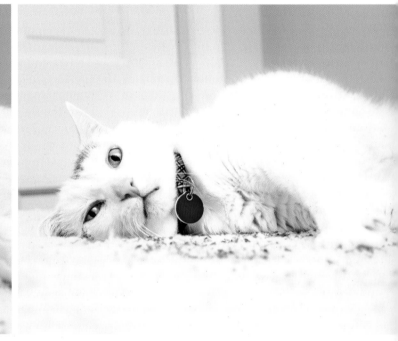

O'NEIL, 11

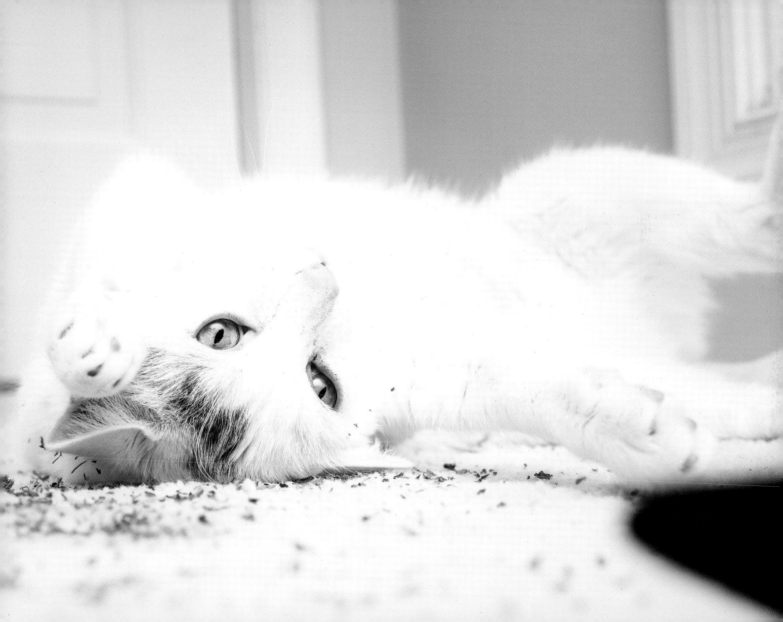

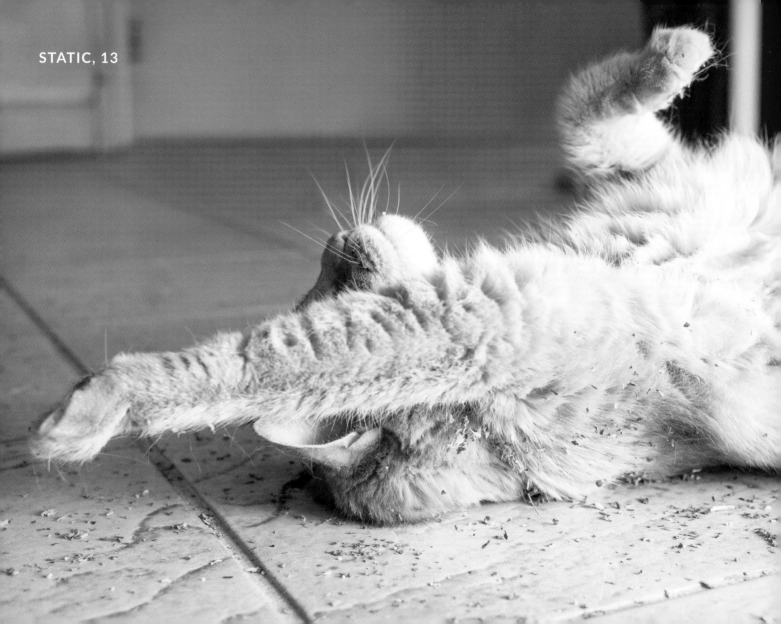

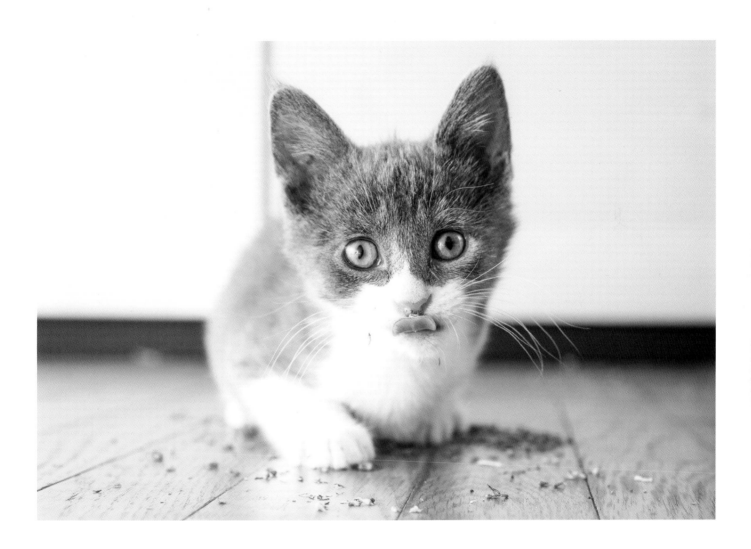

SMALL FRY, 2 months

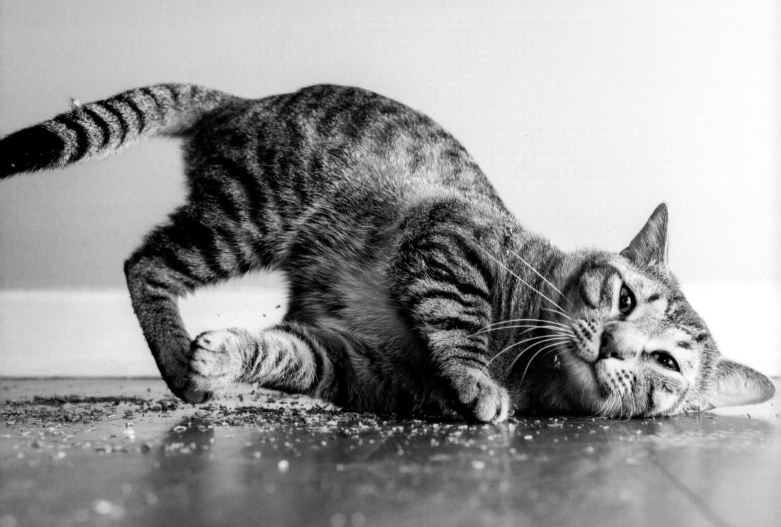

EDGAR, 2

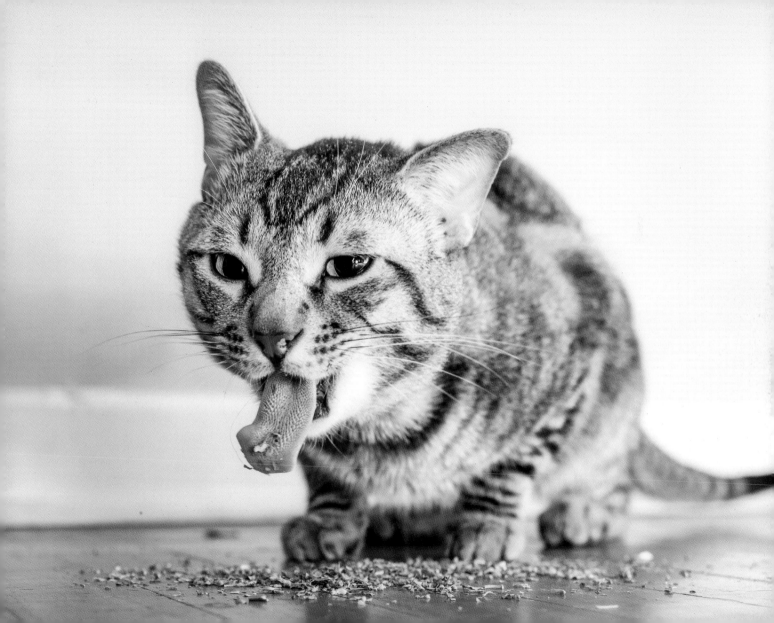

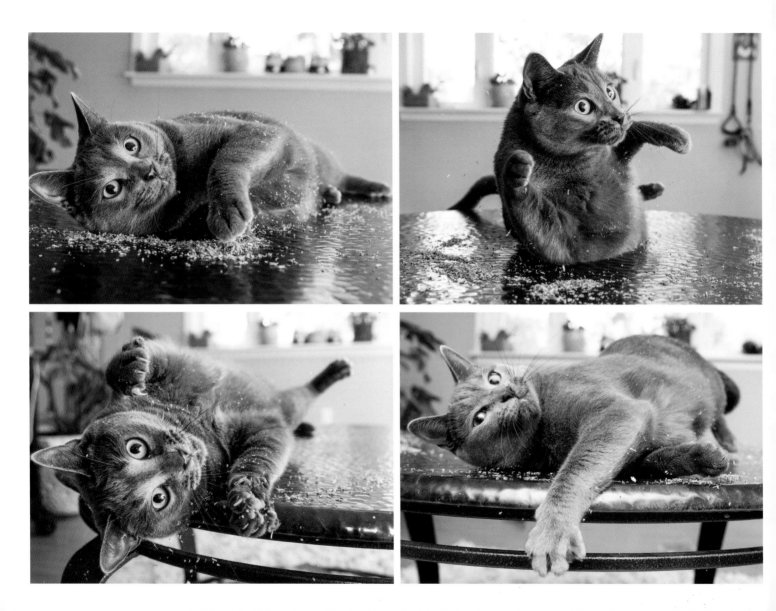

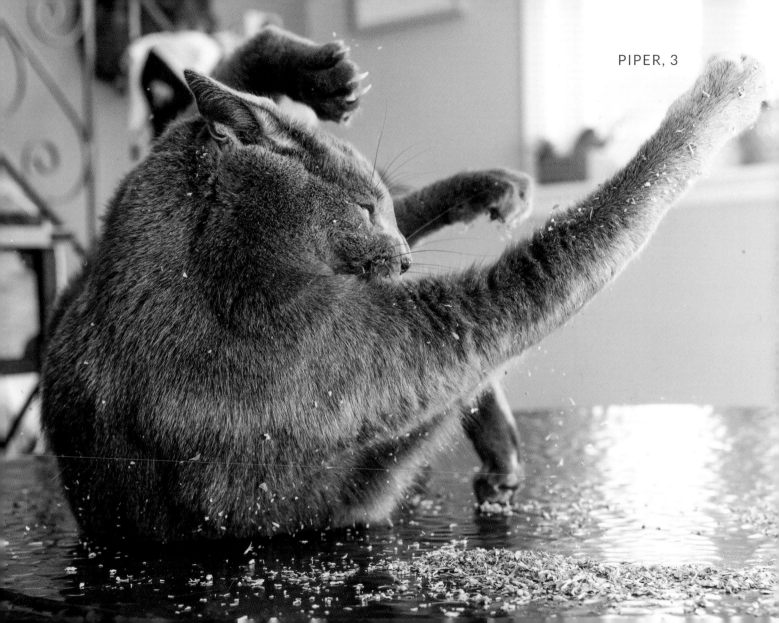

PIPER, 3

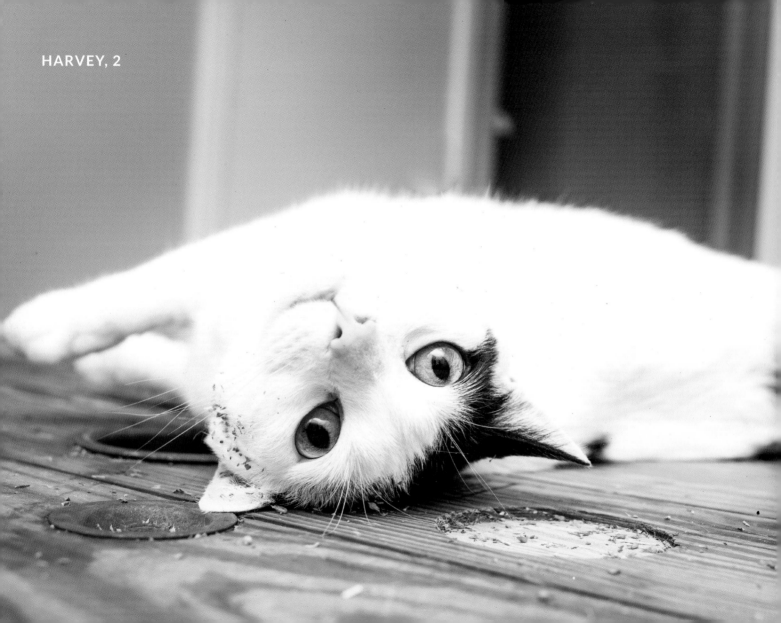

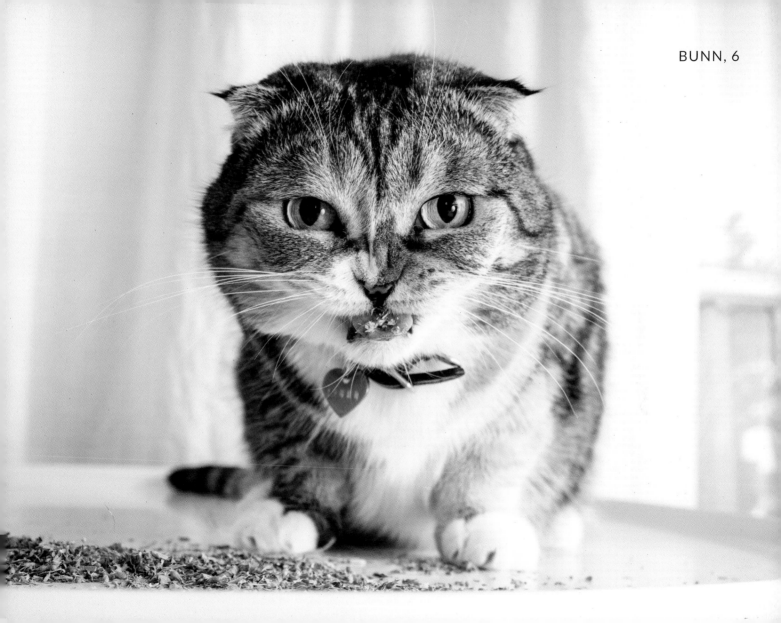

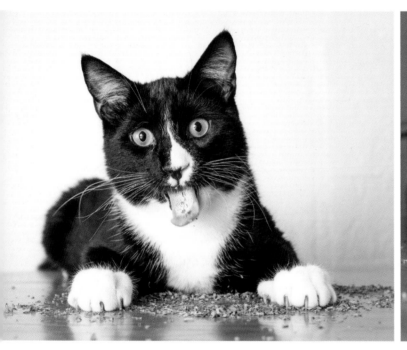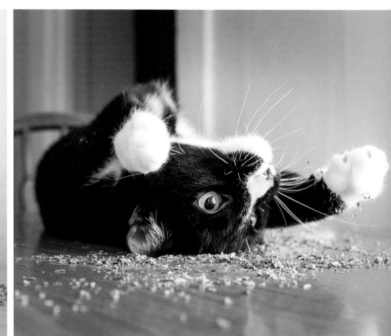

TEXAS PETE, 9 months

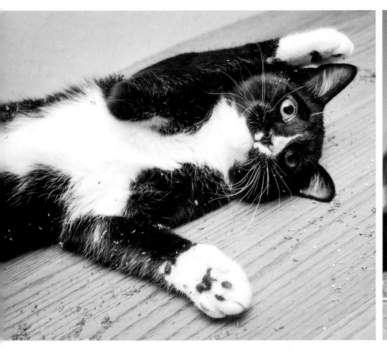
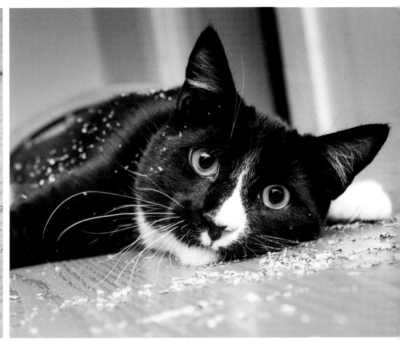

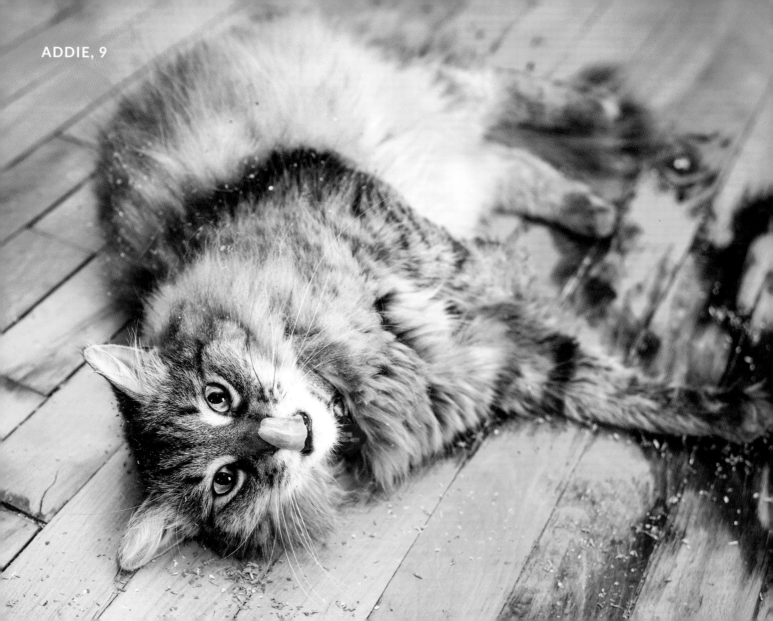

ADDIE, 9

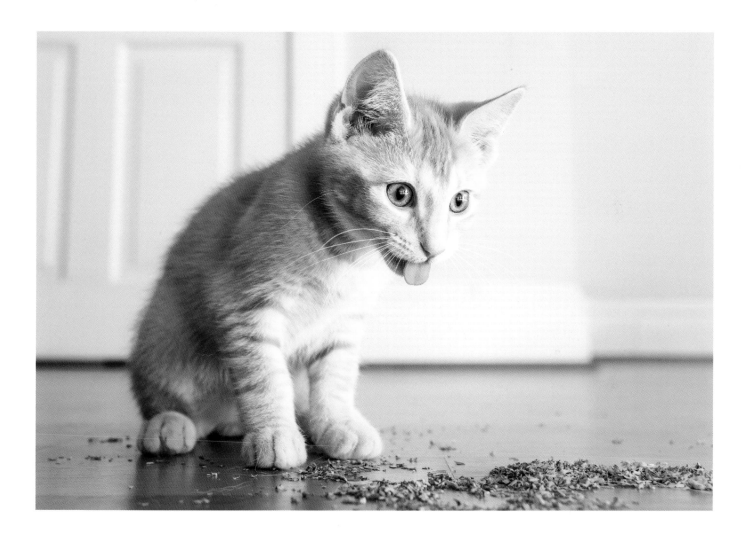

SIMBA, 3 months

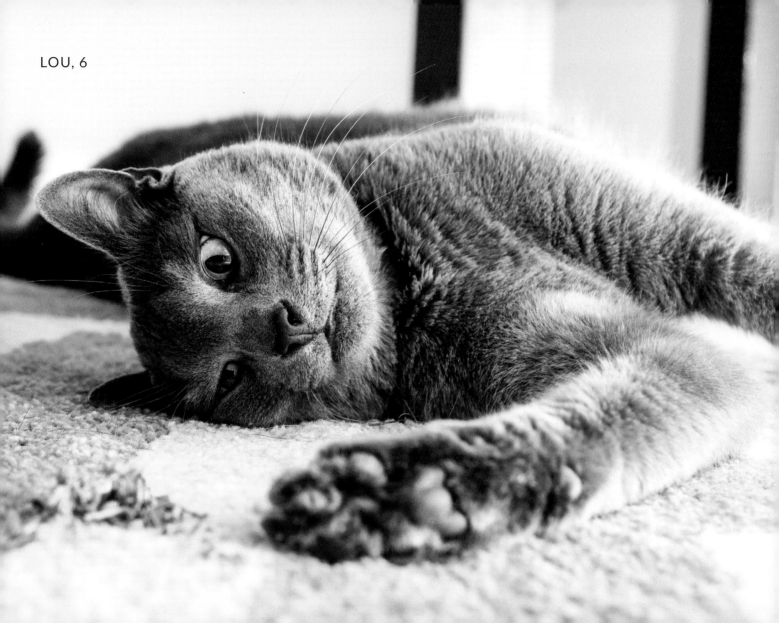

LOU, 6

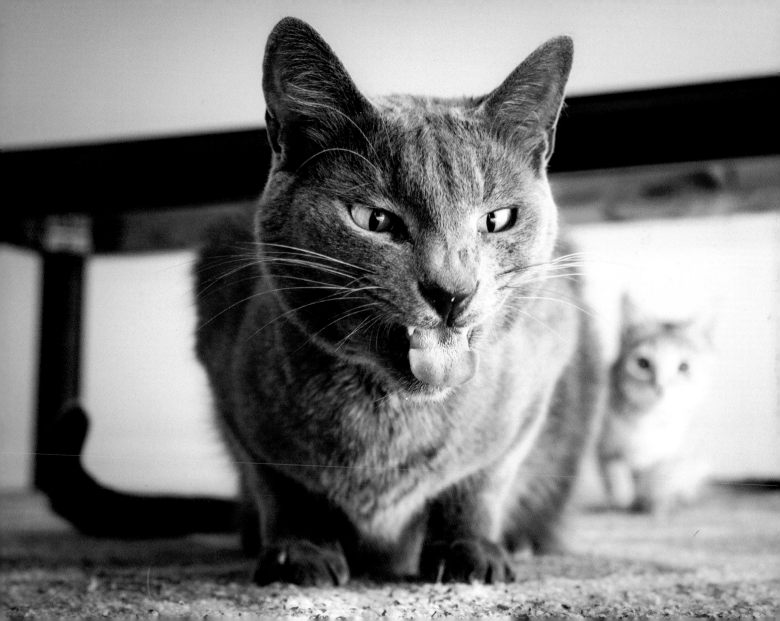

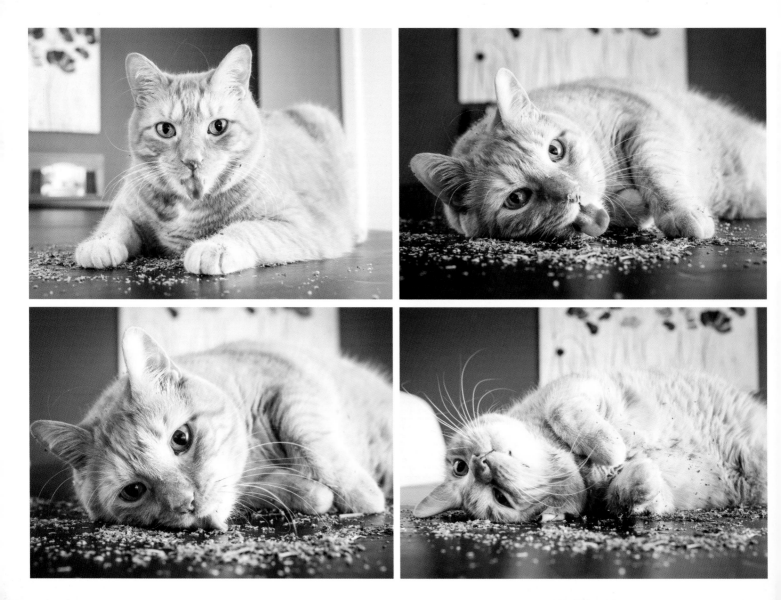

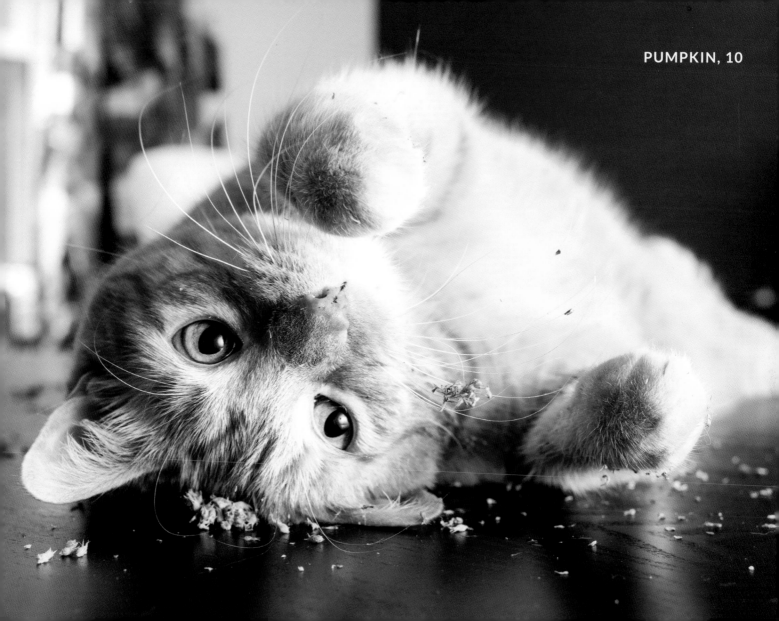

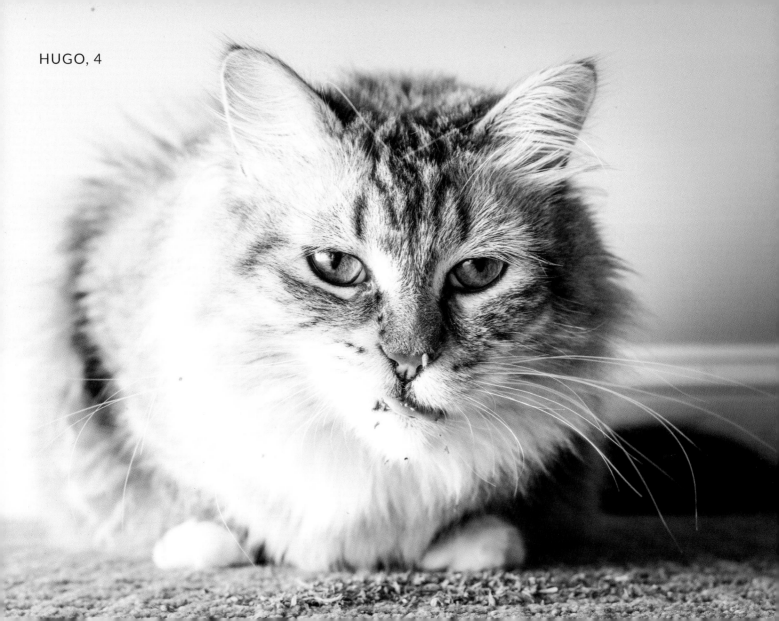

HUGO, 4

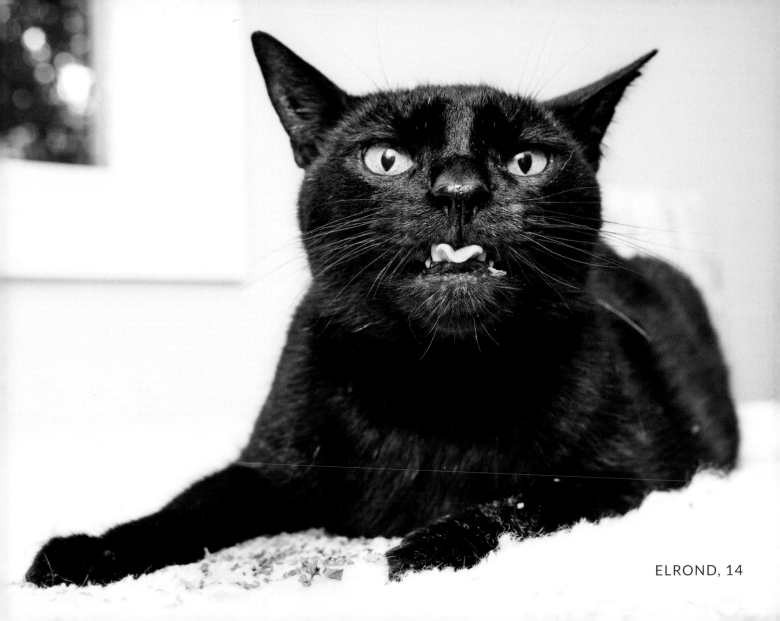

ELROND, 14

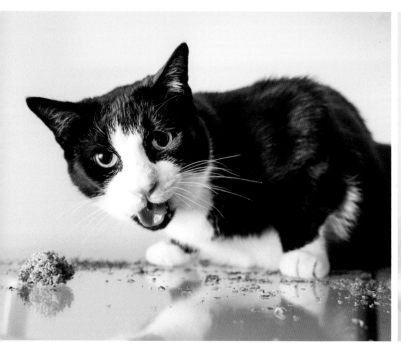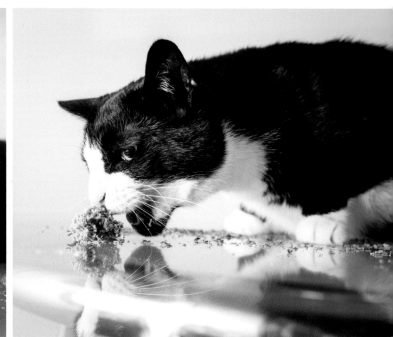

PIPER, 10

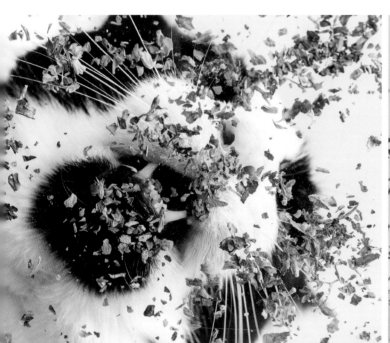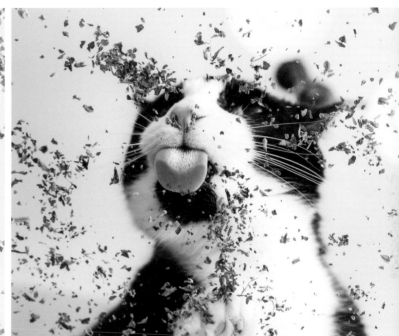

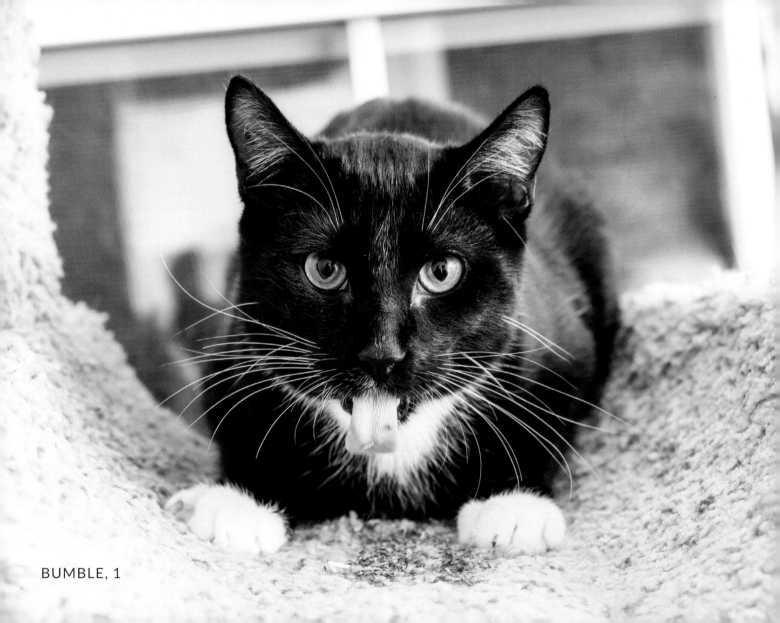

BUMBLE, 1

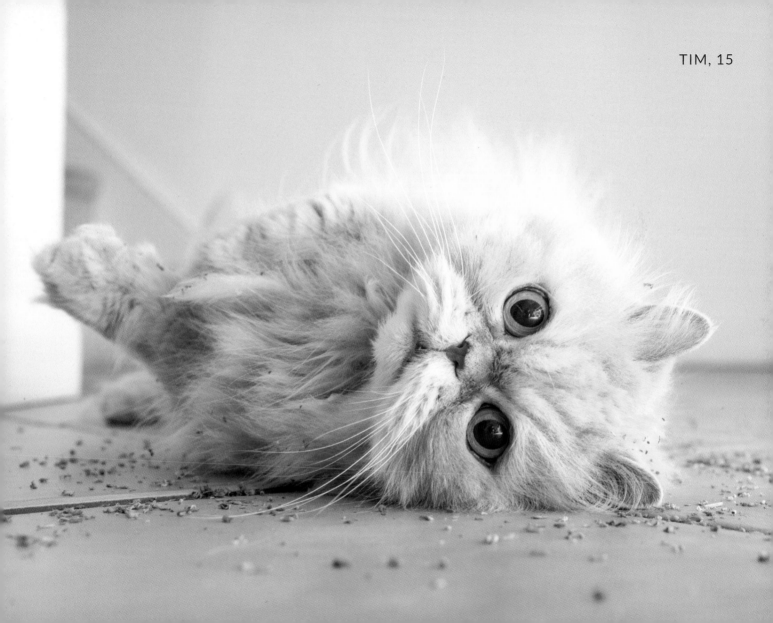

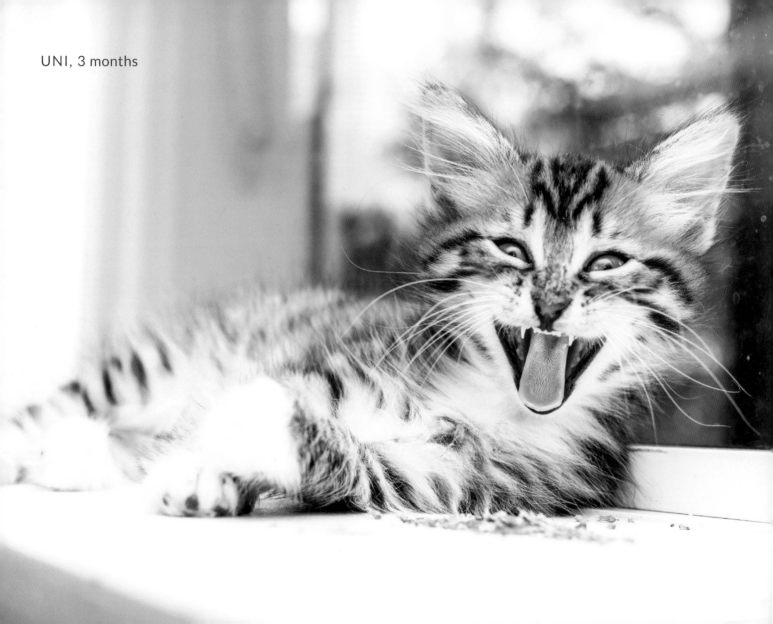
UNI, 3 months

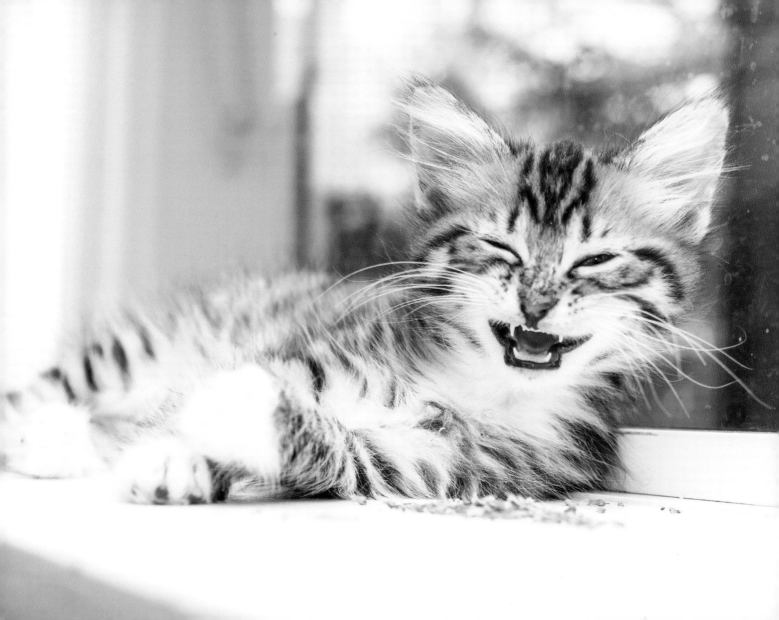

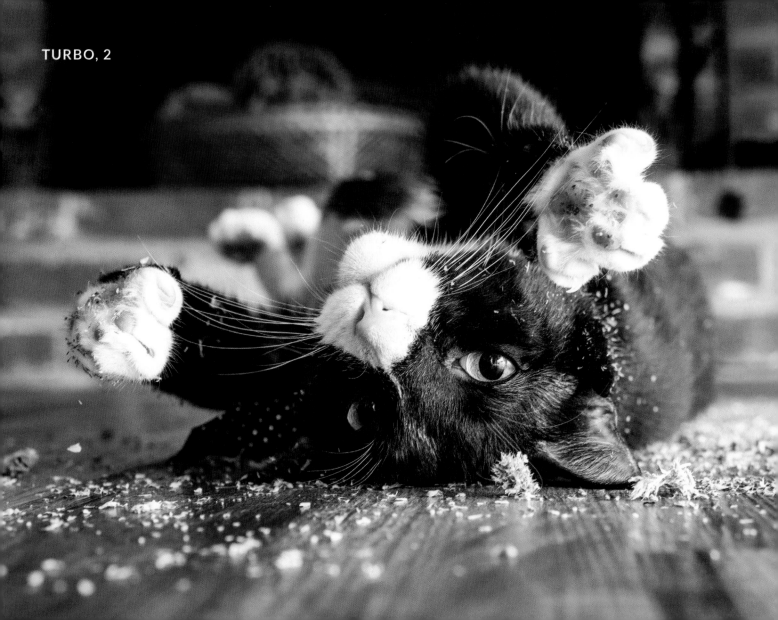

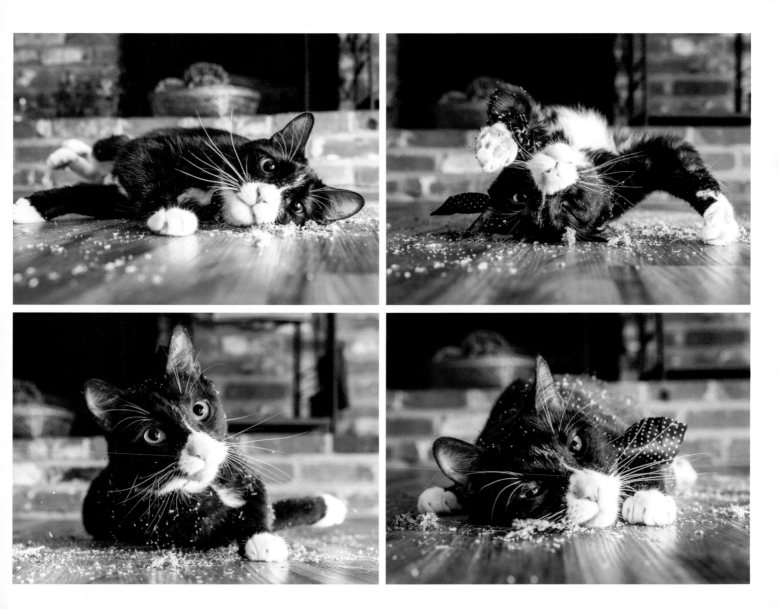

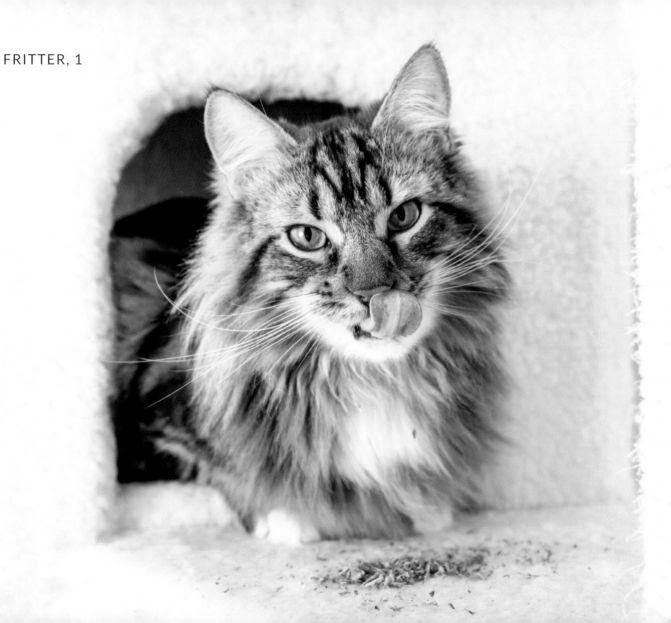

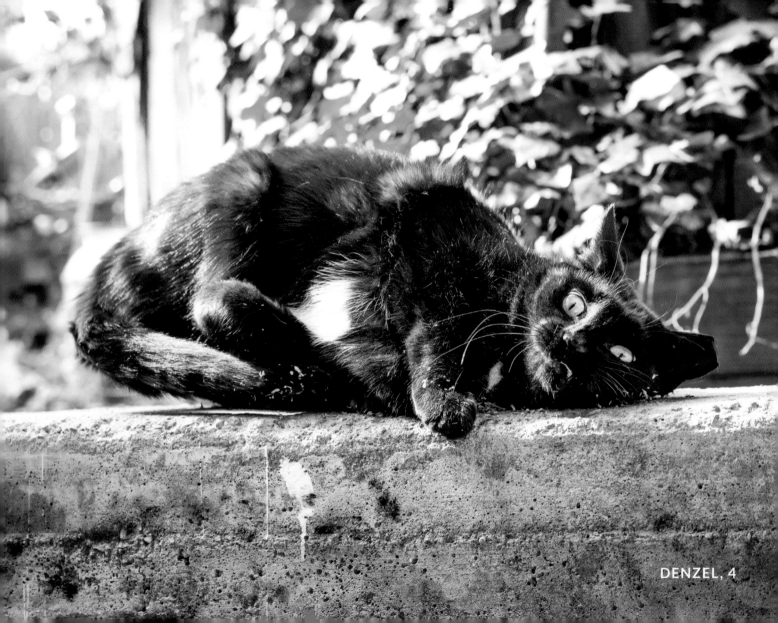

DENZEL, 4

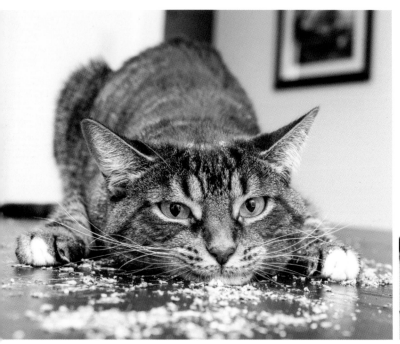
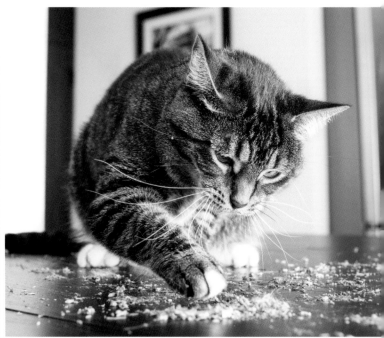

ZAZZLE, 4

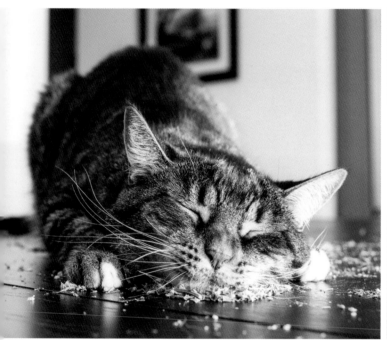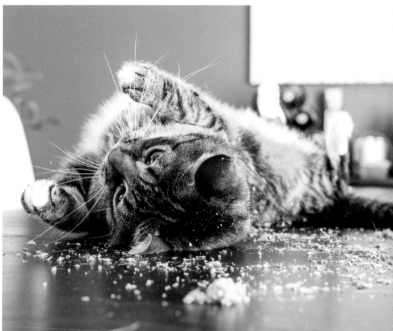

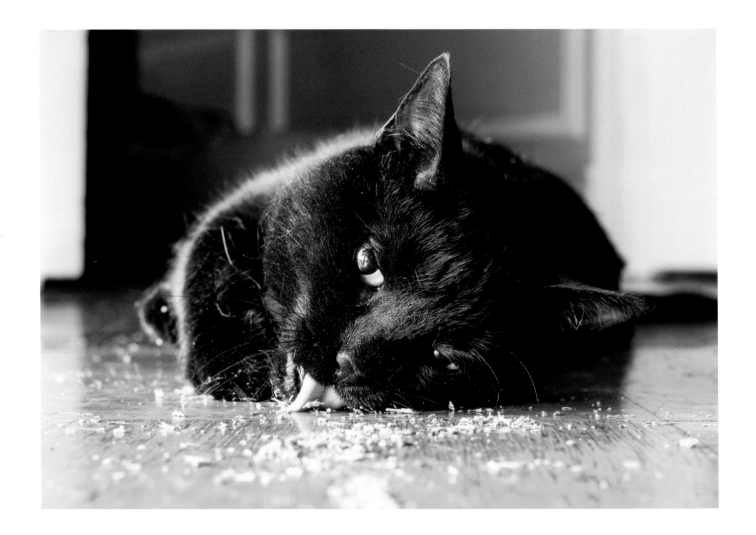

RUBY, 9

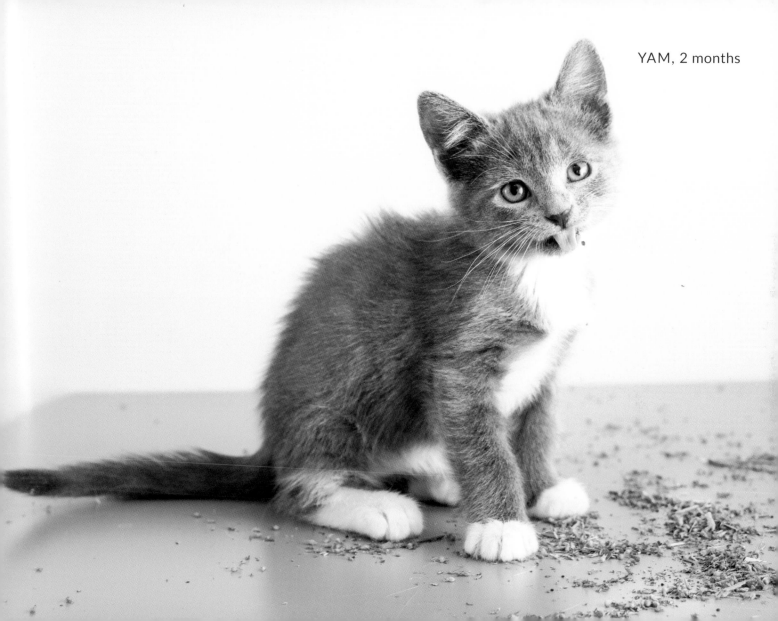

YAM, 2 months

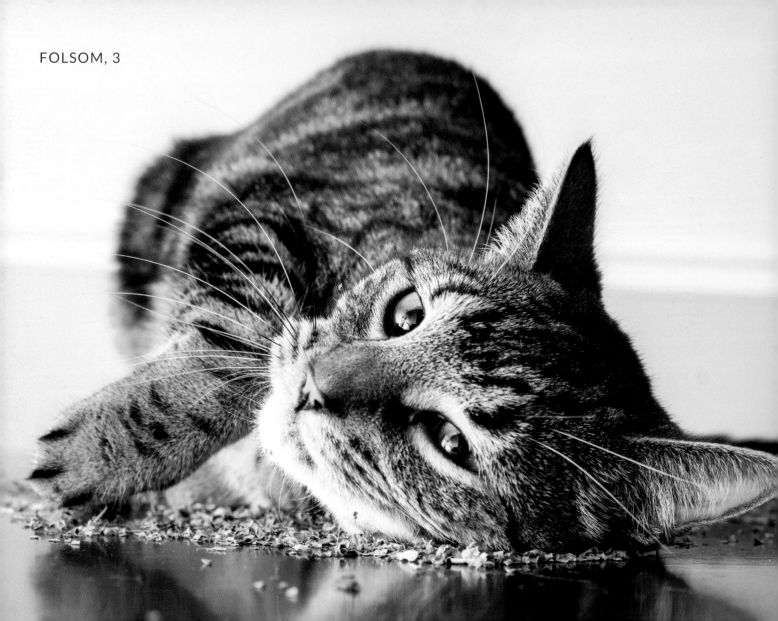

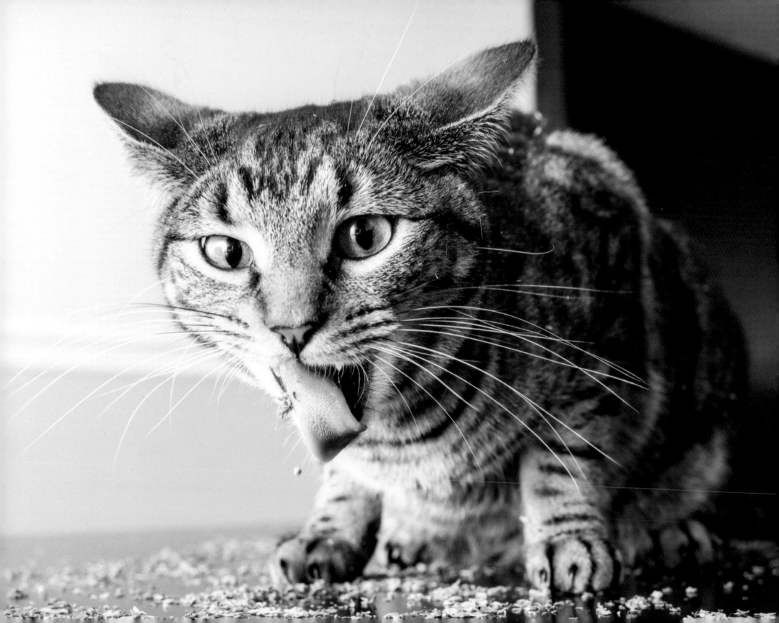

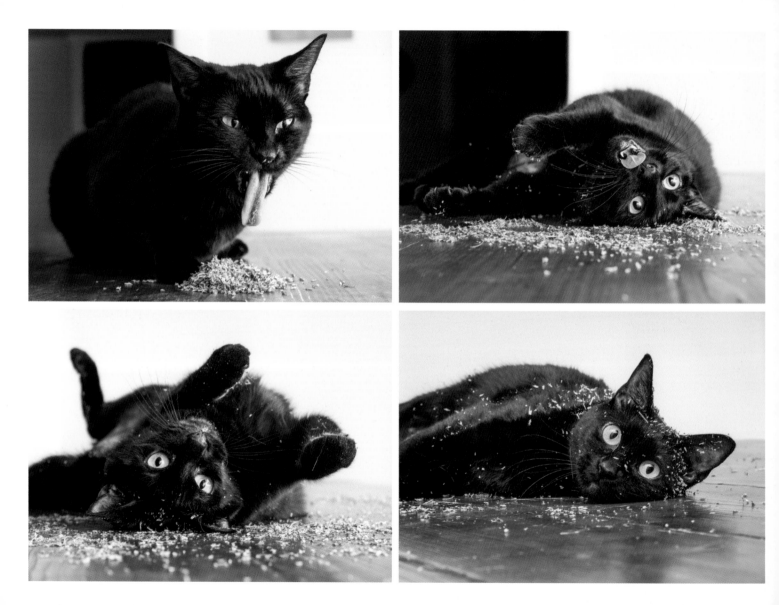

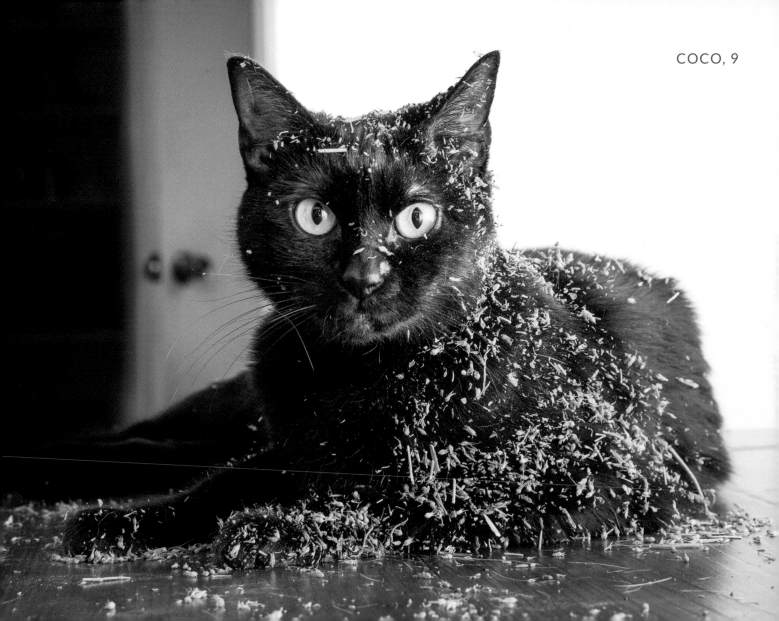

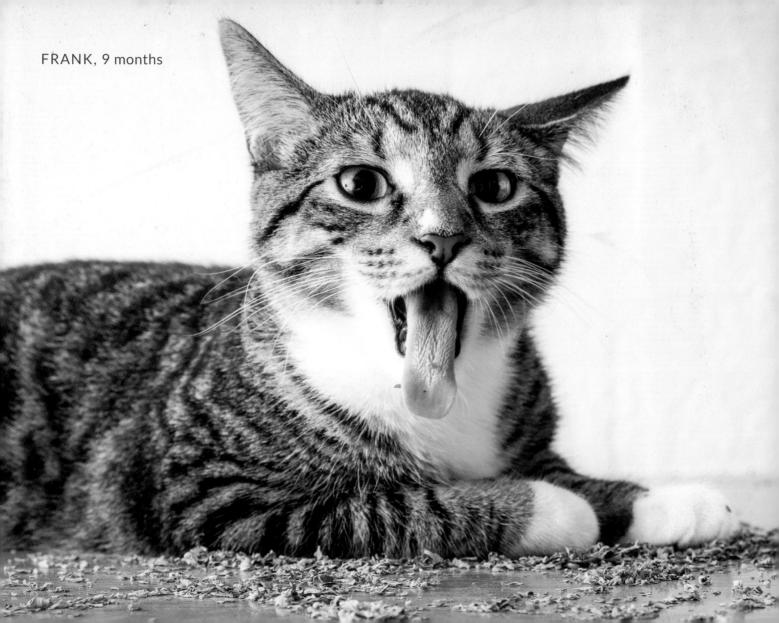

FRANK, 9 months

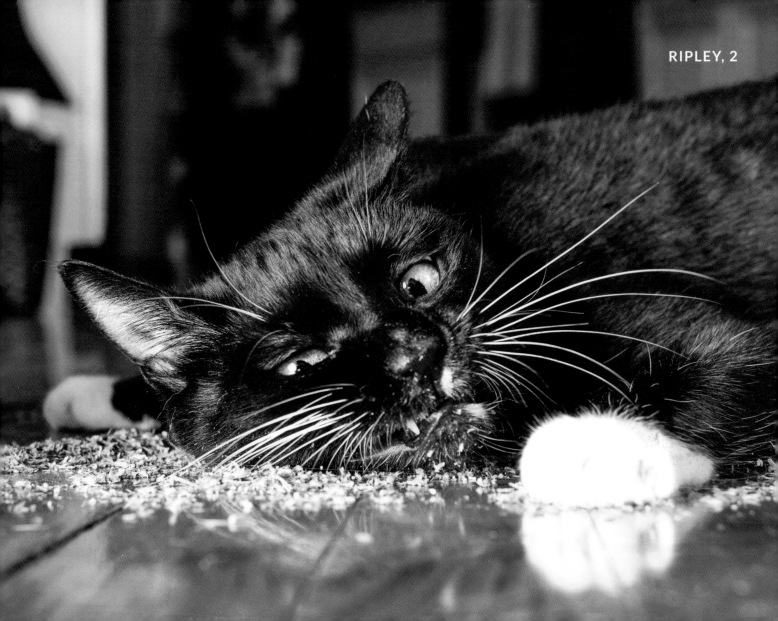

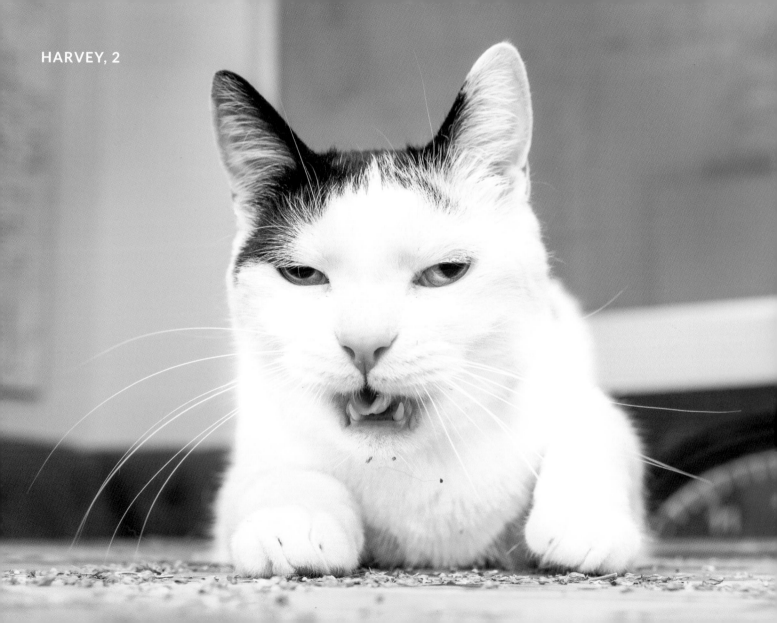

ACKNOWLEDGMENTS

My most heartfelt thanks to my partner Hannah Shaw, who has been my number-one advocate, our permanent cats and revolving door of rescue kittens who have provided innumerable hours of entertainment, love, and opportunities for photos, my family for being ridiculously supportive of this weird and wonderful journey of mine, my agent Lindsay Edgecombe, my editor Jordana Tusman, my designer Ashley Todd, and everyone at Running Press who believed in this bizarre project, and lastly, all of the incredible cats and cat parents I met while making this book.

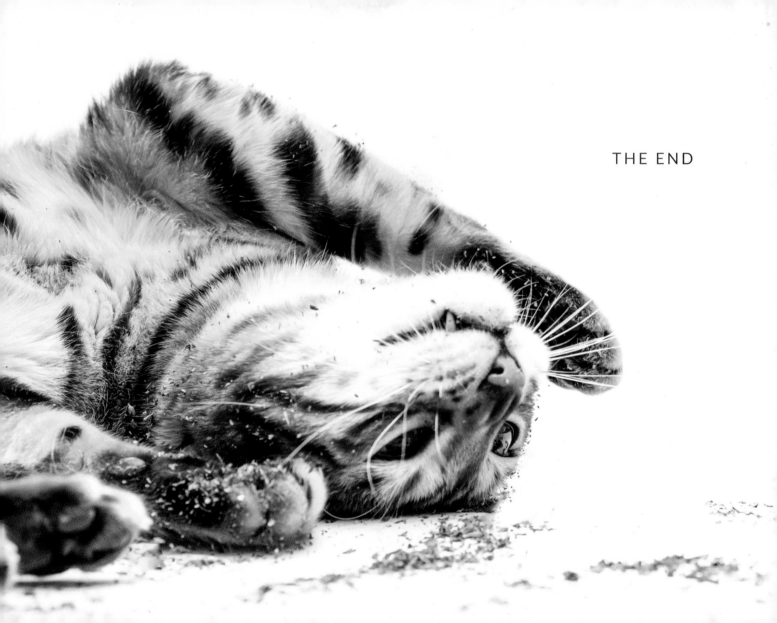

THE END